THE GULF

Prayers by
SHANE STANFORD

Photographs by
ANTHONY THAXTON

Stanford
Thaxton

PUBLISHER'S NOTE: This is the first title to be published by Stanford-Thaxton. There are more titles on the way, and we are always interested in finding new talent. For more information or to submit, please contact us via e-mail: anthony@thaxtonstudios.com

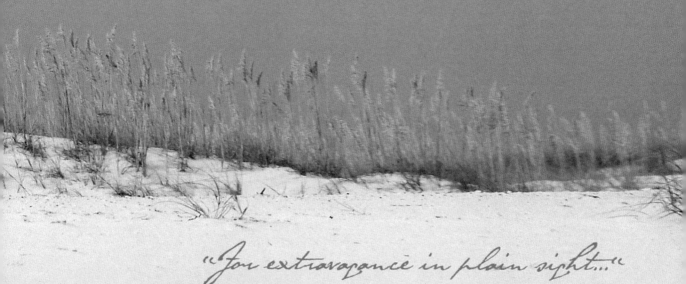

For Anthony- This project began with the incredible talent and images of Anthony Thaxton. It is a privilege to share a small part of something so beautiful and well done. And, so, let me, first, say "thank you" to Anthony for his friendship, partnership and for the opportunity to participate in celebrating God's magnificent creation.

And for Pokey, Sarai Grace, Juli Anna and Emma Leigh- You are my glimpse of God's wonder and beauty each day. Thank you for believing that what I do matters and for celebrating it with such "extravagant" prejudice. I love you all.

- SHANE STANFORD

For Shane- Thank you for your influence on my life. You are a good man, and I'm proud to be a part of what God is doing through you. We've only just begun, my friend.

For Curtis and Linda Thaxton, my parents- Your supportive hearts allowed me to follow the crazy dreams I had, and I'm so proud to have seen so many of them come true. I love you both.

For others who were there for me- Joseph Gregory, Captain John Blanchette, Marijane and M.D. Whitfield, my brother Bobby Thaxton, my sister Michele Seal, Carl Baldenhoffer, Kenneth Quinn, Sam Gore, and my co-workers, past and present.

For Bryant and Sydney- You two are my masterpieces, both beautiful and loved. I am so proud of you.

For my beautiful Amy- Thank you for saving this old Swamp Thing. You've made me a better man. You've believed in me all these years. You are my life. You are incredible. I love you so!

- ANTHONY THAXTON

"For extravagance in plain sight..."

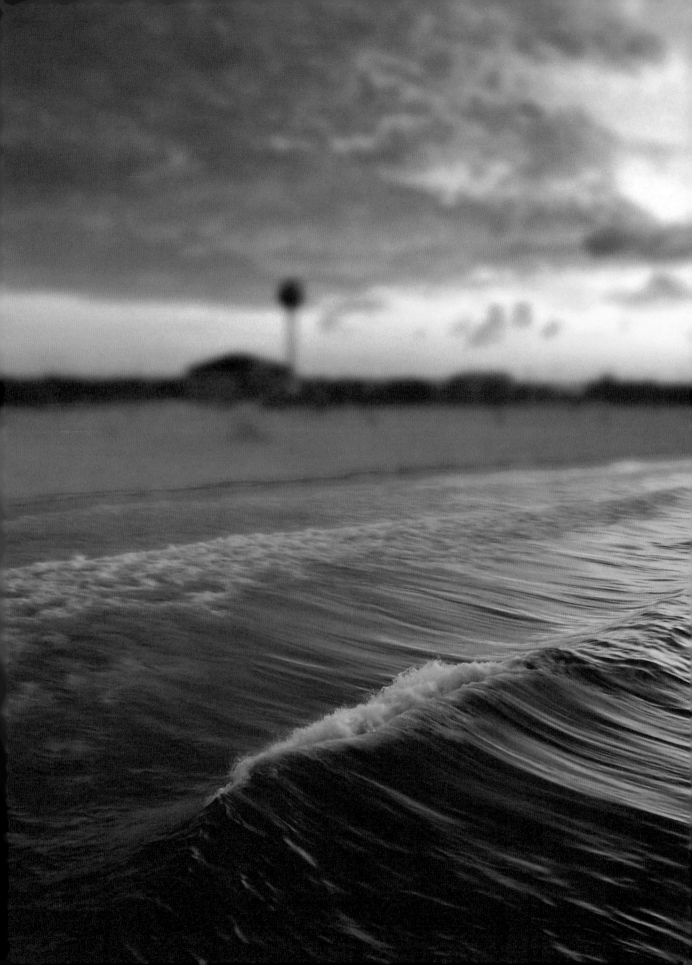

Foreword

BY
ROBERT ST. JOHN

I believe that God lives on the beach, but only at sunrise. In the heat of the day, when the sun is high, I think he hangs out in the cool of the forest. But he always comes back to the seashore at sunset.

For me, those are the two most enchanting dayparts in and around the Gulf. When the world begins to awaken and all is fresh, it signals a new start, a new beginning. No matter what happened the day before, we always have the choice to begin anew.

At the close of the day when the sun is low, the pace has slowed, the shadows are long, and the colors are— sometimes vivid, sometimes muted, but always— picturesque, we think not of endings, but of the joys we have just experienced and of the surety of the new launch that will greet us the next day.

Famed Mississippi artist, Walter Anderson, called dusk in and around the Mississippi Barrier Islands "The Magic Hour." Though the beauty of a Gulf sunset might seem "magical" to some, I don't think there is anything supernatural about it. The beauty is intentional. It is a daily reminder that a loving God— one who can paint the late afternoon sky with a sure brush, using a palette of infinite colors— is alive and living in us, and among us, every day.

There is something mesmerizing in the Gulf's sensory trinity: The mixture of salt air, the steady sound of surf, and the splendor of the Southern sunset. It's a barefoot cathedral worthy of any gilded structure in Europe. For on the beach, and through its

beauty, I am aware of— and in contact with— a forgiving God, who is, without question, the Creator of all things.

The book that you hold in your hands is verifiable proof of "That which is beautiful begats that which is beautiful." The magnificence of the Gulf region served as the inspirational muse for the insightful and ruminative prayers of Shane Stanford and the world-class photography of Anthony Thaxton.

For those who live near the seashore, this volume will be an all-to-familiar reminder to show gratitude to the Lord every day for the privilege of being able to live surrounded by His most beautiful works.

For those of us who are landlocked, we remember back to earlier times when a father held the hand of a son as he felt sand between his toes for the first time, to the carefree days of youth, to weddings and celebrations, and serious moments of meditation, reflection, and prayer. The beach is the inspiration, it is the constant.

God did some of his best work in His oceans and on their shores. That is why he devoted almost 3/4 of his labors to the earth's waters, and on the first day as it happens. Stanford and Thaxton, a duo at the top of their game, have delivered their best work as well.

The Gulf is a testament to the wonderment that surrounds us in the world that God has made. It celebrates the beauty and joy that is life in and around the Southern coastline whether in early morning, dusk, or the heat of the day.

ROBERT ST. JOHN

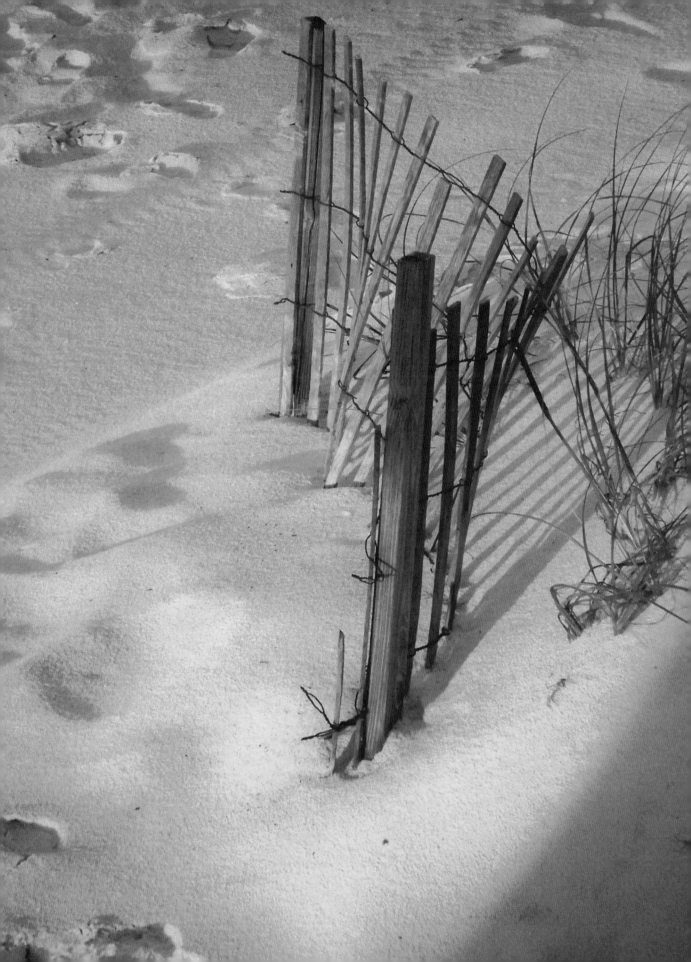

Introduction

BY

ANTHONY THAXTON

A magazine in Mississippi once published a pictoral essay of some of my photographs calling it "The Coast." What was very interesting to me was, though I took all of the photos in this book except for the one on the opposite page, I am not a photographer. I had taken the dust jacket photograph of Wyatt Waters used on several Christmas books that contained short stories and his artwork, but I have basically always been a painter. In fact, I had previously written 7 or 8 columns in that same magazine, and the columns were accompanied by my watercolor paintings.

When speaking to the editor about upcoming "Southern Sketches" spreads, the editor mentioned wanting to include something about the Mississippi Gulf Coast. I casually suggested that a spread of photos would be something different, an essay of southern Mississippi places where I had lived and grown. She looked at the pictures and printed them in the next issue. It was my first public showing of my photographs.

Not being a full-time artist, I've rarely had chances to paint for long stretches of time on location. I've always had to take photographs as tools to use later for paintings. It never really registered with me that the photos themselves could be works of art. In short, I've never taken photography seriously.

Until a year ago.

I accepted a job as Creative Director at Gulf Breeze United Methodist Church and moved my family to Florida. Right before the move, I also purchased a new camera.

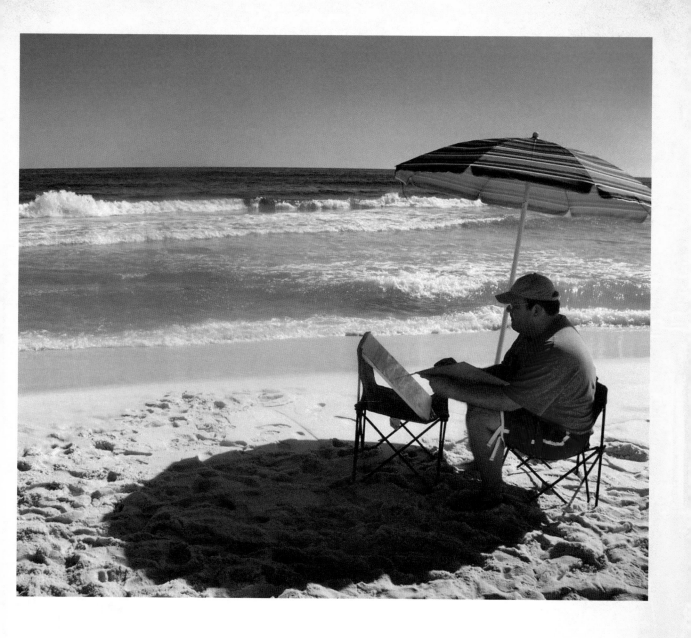

From the first here in Florida, I have felt compelled to take lots of photos, more than I've ever taken before- not just of my terrific children (Bryant and Sydney), but of all the outdoors around me. It's been liberating and wonderfully exciting. I could go for a sunset trip to Fort Pickens, take 60 or 70 pictures, and end up with 3 or 4 really good ones. What fun to see an osprey building a nest or watching the surf do it's thing or driving past Mississippi Coast light-houses or stalking pelicans in crazy places. Frankly, I've been in heaven. And the more photos

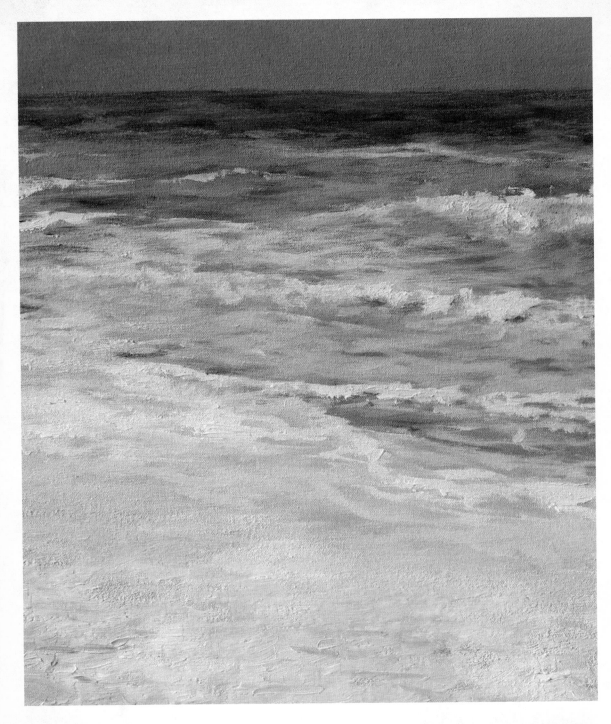

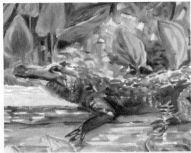

I've taken, the more I've felt compelled to keep taking. I never really knew what I would do with all of these photographs, however.

Then came the oil spill.

Our world was shattered as the Horizon deep sea rig sunk and millions of gallons of oil began spewing into our beautiful gulf. (As of this writing, the crude continues to spill out, every hour, more and more).

I've seen grown shrimpers cry and mothers filled with anger and frustration. I've watched my precious Amy's heart breaking as she quietly watched the latest news. I have stood at early sunrise on a Pensacola pier next to a Vietnamese fisherman who quietly pointed to the first oil. "It over," he said.

On that morning when the oil came, I could think of nothing to say. I simply took pictures (and that man's portrait is included in this book). I snapped around 100 shots that morning, trying to capture the beauty around me while I could, the beauty of a beach sunrise that brought with it change. I wished there was something I could do, but I just took photographs.

But, it will take more than oil to destroy the gulf, to destroy Coast people. My friend Jack Kale, who pastors a beach-side service called Worship At The Water, said it best when he said we'll clean this mess one grain of sand at a time.

God knows something about grains of sand. He knows each of them, as He knows each of us. God knows my Vietnamese friend, and He cares for him. God knows Jack and hears the prayers of those gathered at Flounders. God sees my father (Curtis) and my brother (Bobby) who have fished the Mississippi marshes their entire lives and who have braced themselves for losing it all. He has not forgotten. God knows their hurts And He hears our prayers.

This book began as therapy for me, and it has turned into something more. It has turned into a labor of love. It's not much, but like one of Shane Stanford's book titles says,

"You Can't Do Everything, So Do SOMEthing." This book is our attempt at just doing something.

I hope these photographs will give you some comfort. Taken in Mississippi and Louisiana fishing spots, in Mobile Bay of Alabama, on the majestic Emerald Coast of Florida, these photos are an offering to you. May you pray along with Shane's beautiful prayers. For the Creator who knows each grain of sand wants to, I believe, bring you comfort in this crisis. He can do mighty things, majestic things, as the grace and wonder of His creation proclaims.

I pray you'll feel His strength and see His glory in a very real way. I have felt it. I have seen it.

Thanks for letting us share The Gulf with you.

ANTHONY THAXTON

PRAYER ONE

Creation

Gracious God,

We are amazed at
Your Creation.

The perfection of so much
from one.

The purpose of such complexity
from simplicity.

The presence of such peace
from chaos.

We are in awe of how you put
all things in their places
and yet still allow even the
smallest things to grow
and blossom.

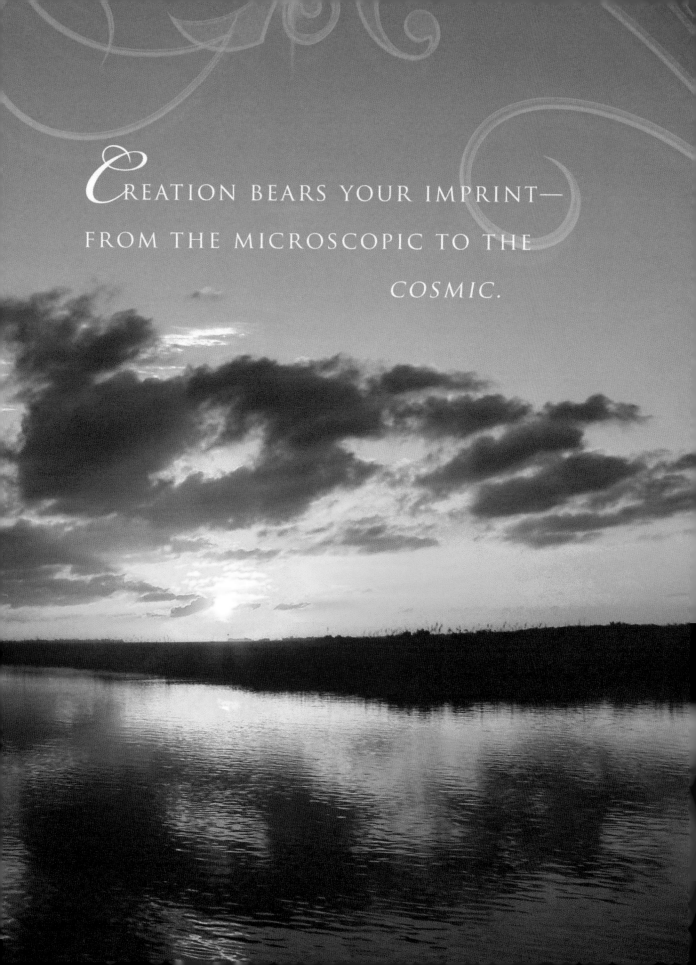

CREATION BEARS YOUR IMPRINT—
FROM THE MICROSCOPIC TO THE
COSMIC.

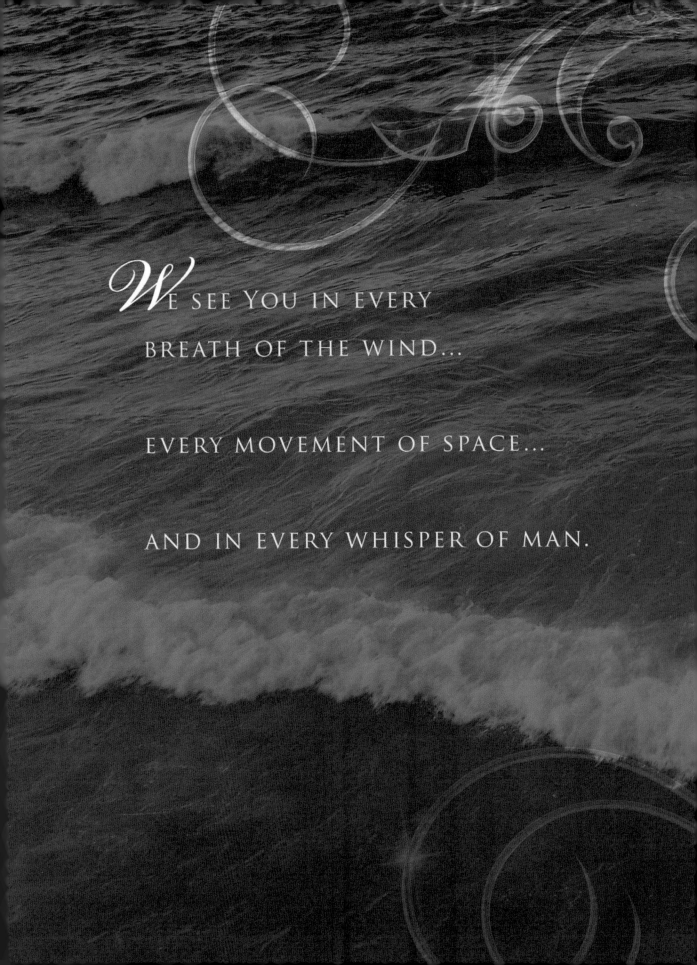

WE SEE YOU IN EVERY
BREATH OF THE WIND...

EVERY MOVEMENT OF SPACE...

AND IN EVERY WHISPER OF MAN.

WE ARE BLESSED—
FOR WE BELONG TO
YOUR CREATION..

FROM YOUR HEART...

FOR ALL ETERNITY.

"*A*ND, NOTHING... NOTHING...

NOTHING...

SHALL SEPARATE US FROM

YOUR GREAT LOVE."

AMEN.

Romans 8

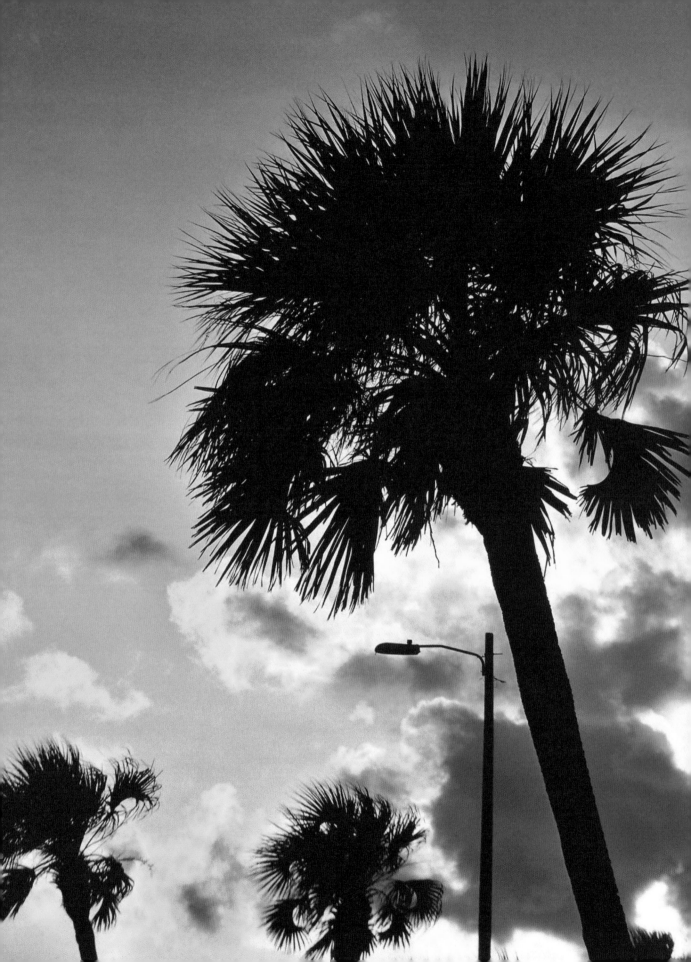

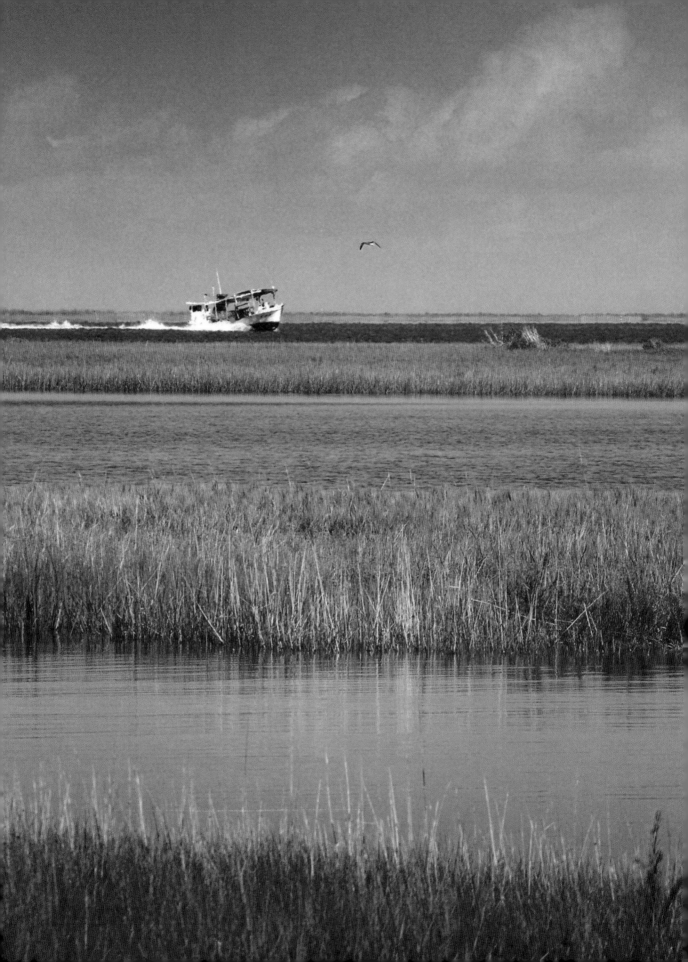

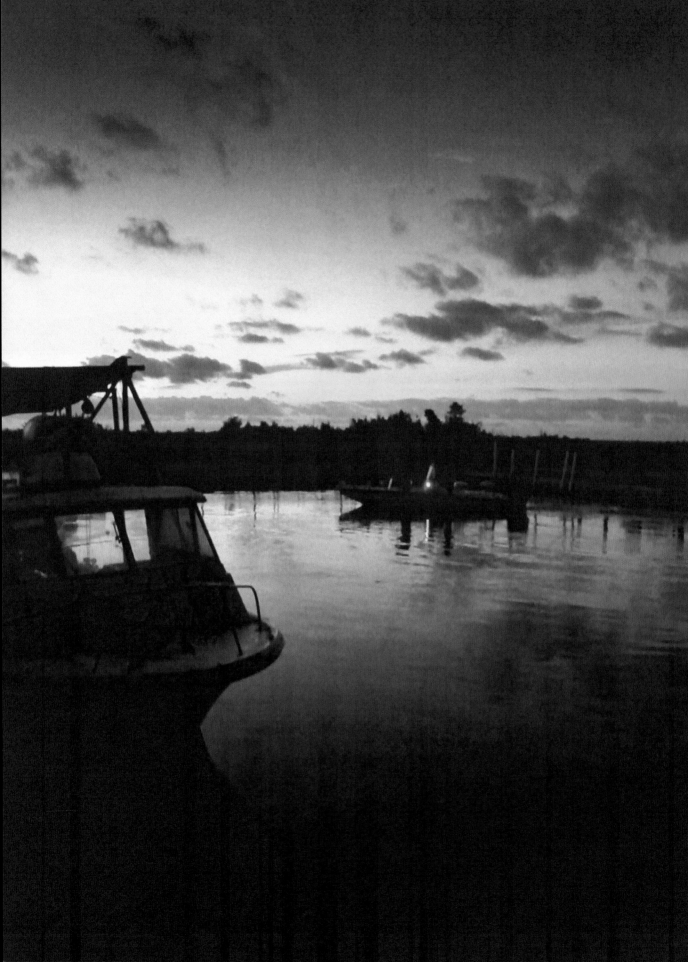

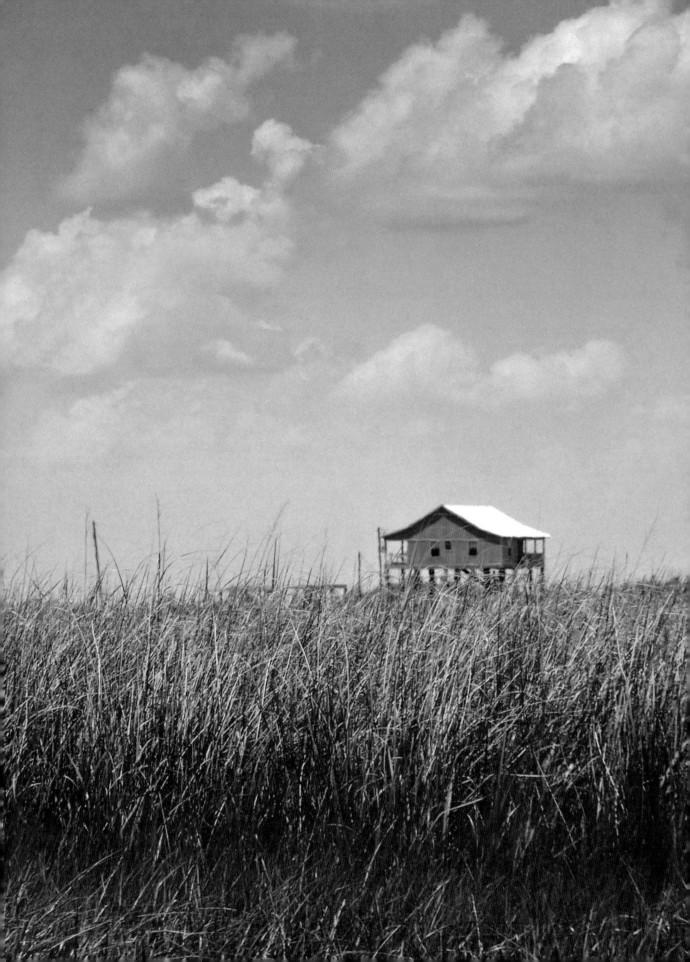

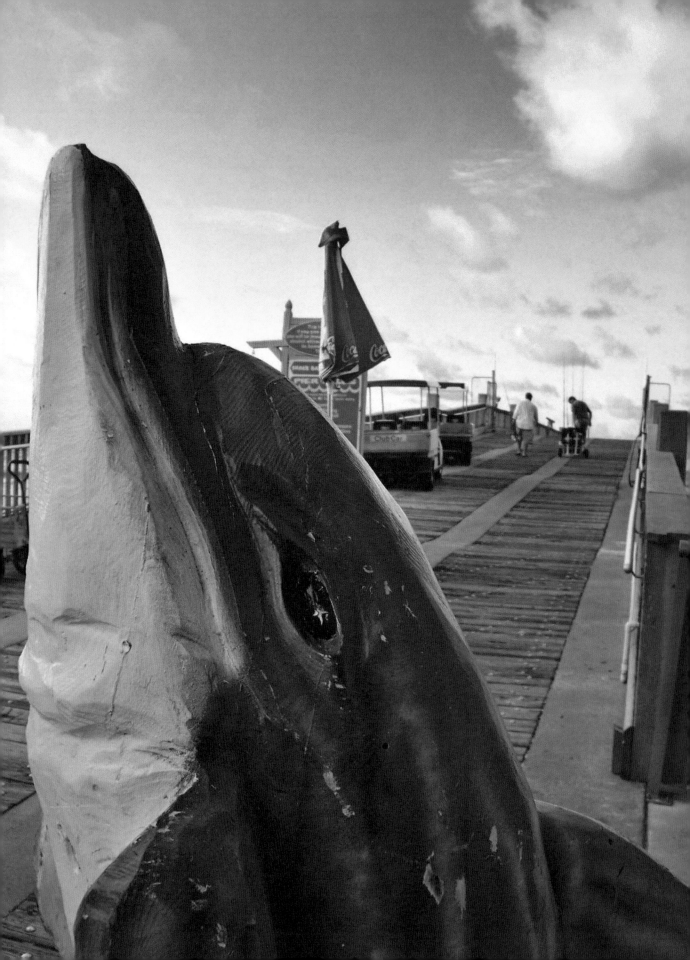

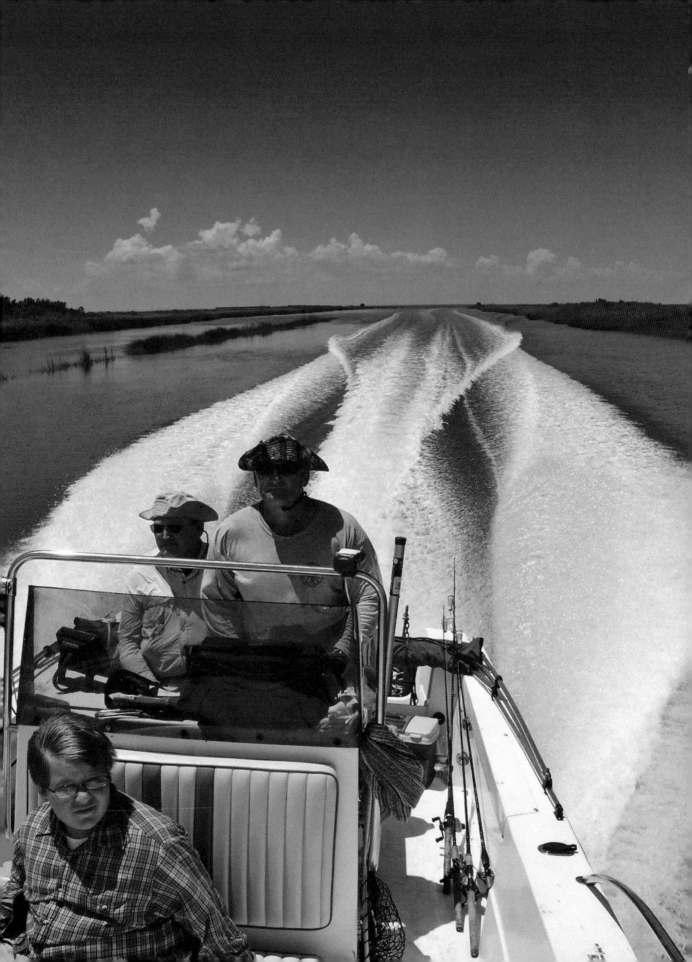

PRAYER TWO
Goodness

GRACIOUS GOD,

WE ARE AMAZED AT YOUR GOODNESS.

THE SOUL OF THE OCEAN KISSES

THE SHORE AS A MOTHER

EMBRACES A CHILD.

The storms rise but only for a season—for the heart of your creation knows a better image--- a softer place.

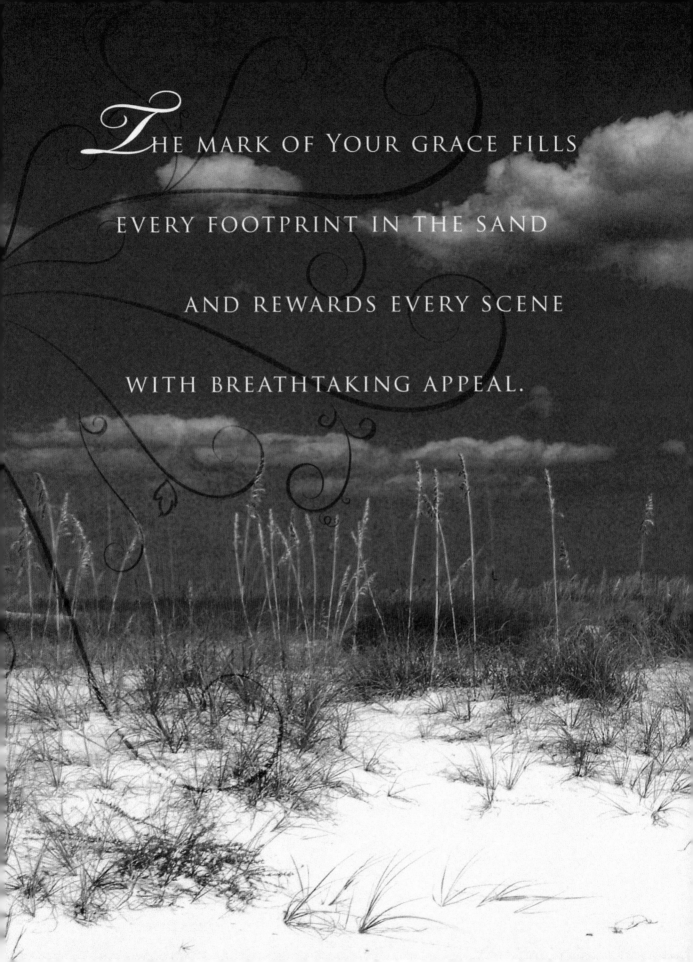

THE MARK OF YOUR GRACE FILLS

EVERY FOOTPRINT IN THE SAND

AND REWARDS EVERY SCENE

WITH BREATHTAKING APPEAL.

Goodness

For who could doubt

YOUR PRESENCE

WHEN CONFRONTED BY

YOUR MASTERPIECE.

THE SUN AND MOON DECLARE

YOUR ORDER...

THE WAVES AND HORIZON SING

OF YOUR NATURE...

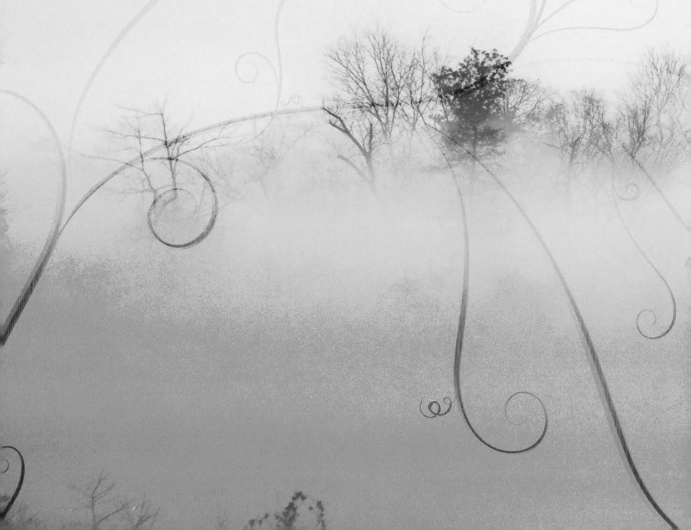

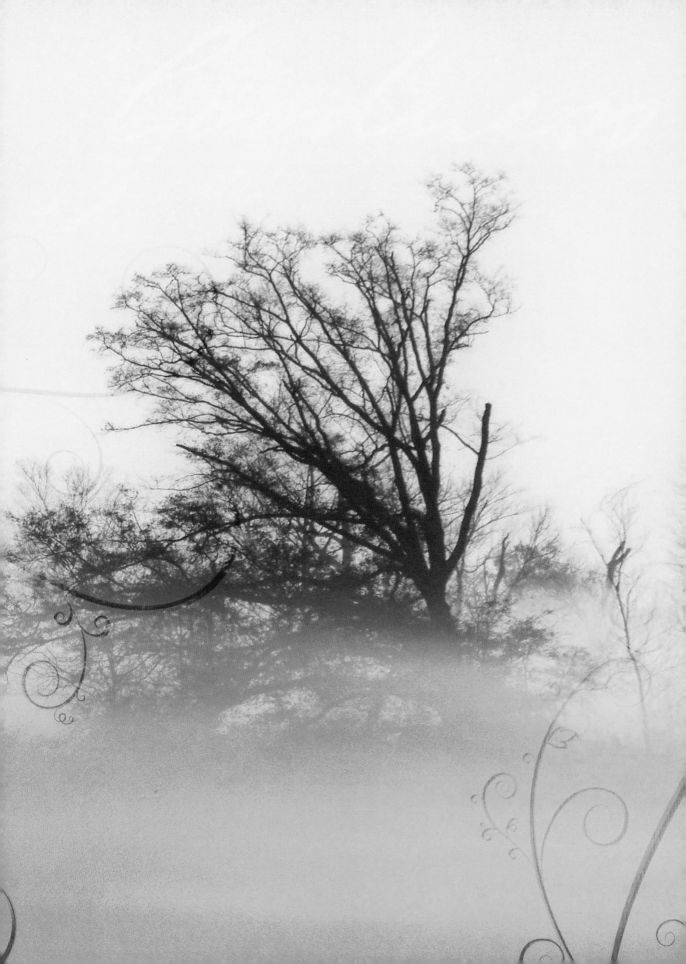

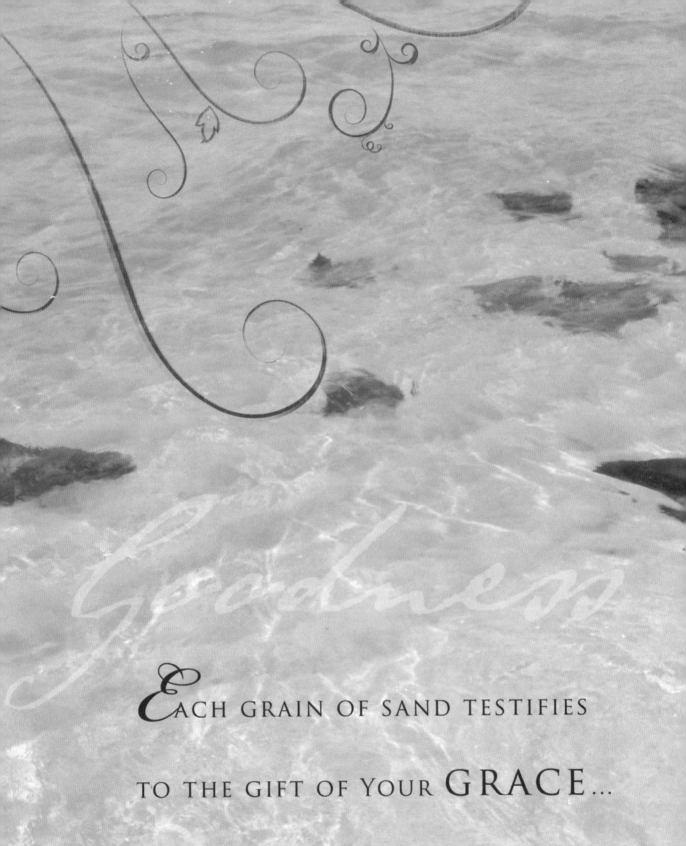

Goodness

\mathcal{E}ACH GRAIN OF SAND TESTIFIES

TO THE GIFT OF YOUR GRACE...

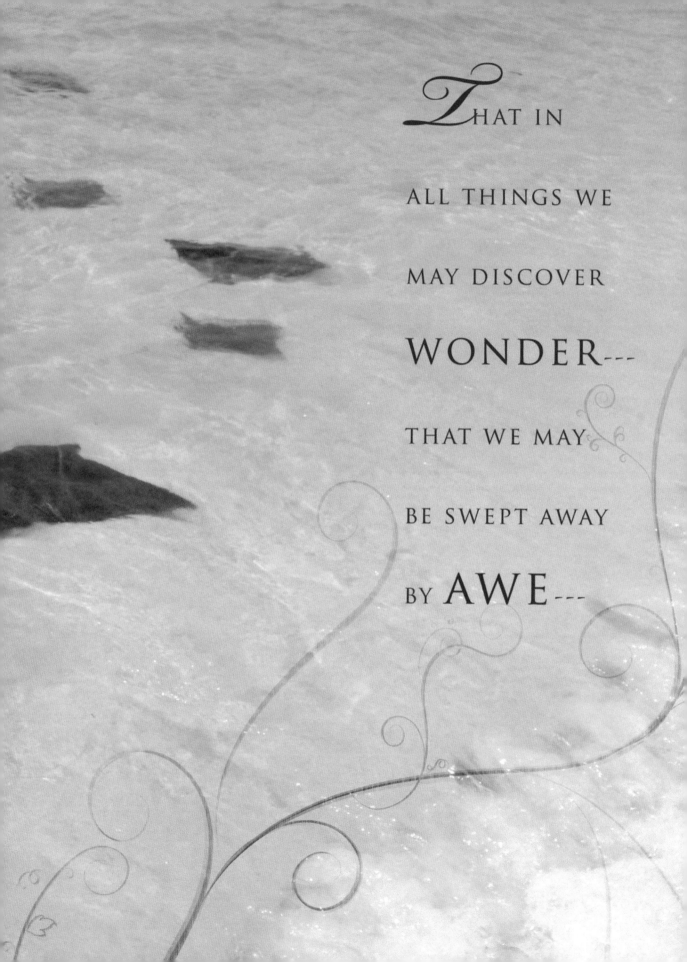

*T*HAT IN

ALL THINGS WE

MAY DISCOVER

WONDER---

THAT WE MAY

BE SWEPT AWAY

BY AWE---

*T*HAT WE MY BE

OVERWHELMED BY GOODNESS.

CREATION SPEAKS TO MORE

THAN ITS EXISTENCE...

IT SPEAKS TO THE

ONE THROUGH

WHOM EXISTENCE

BECAME...

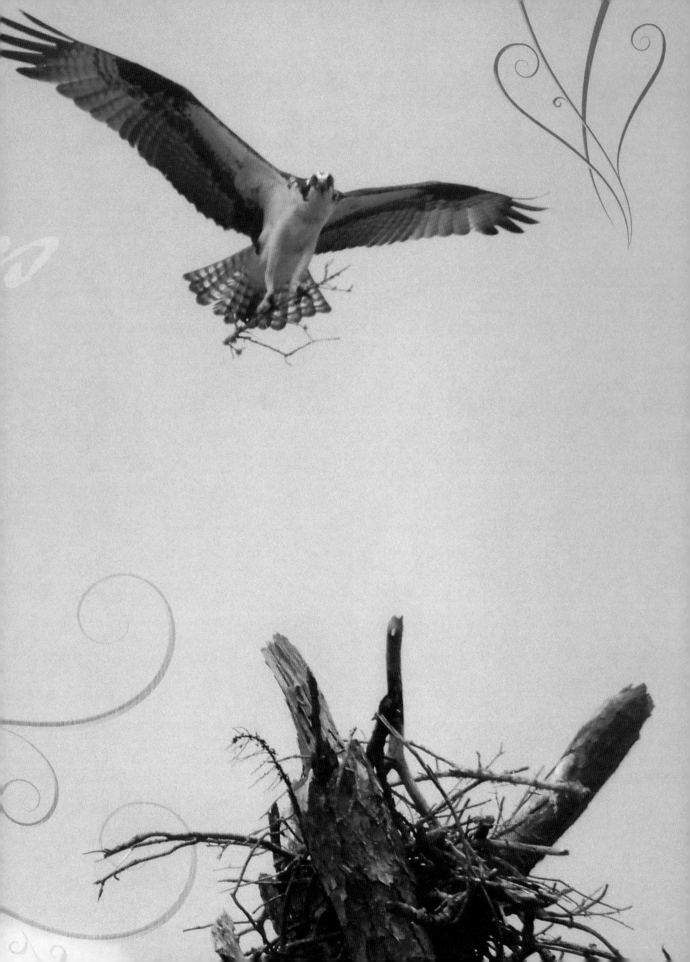

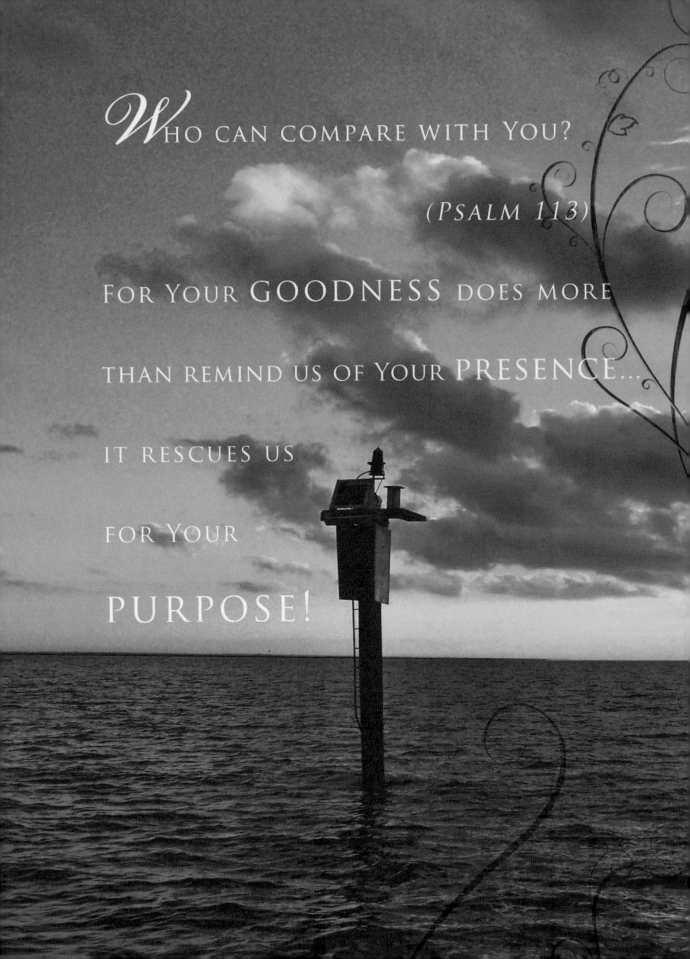

Who can compare with You?

(Psalm 113)

For Your GOODNESS does more

than remind us of Your PRESENCE...

it rescues us

for Your

PURPOSE!

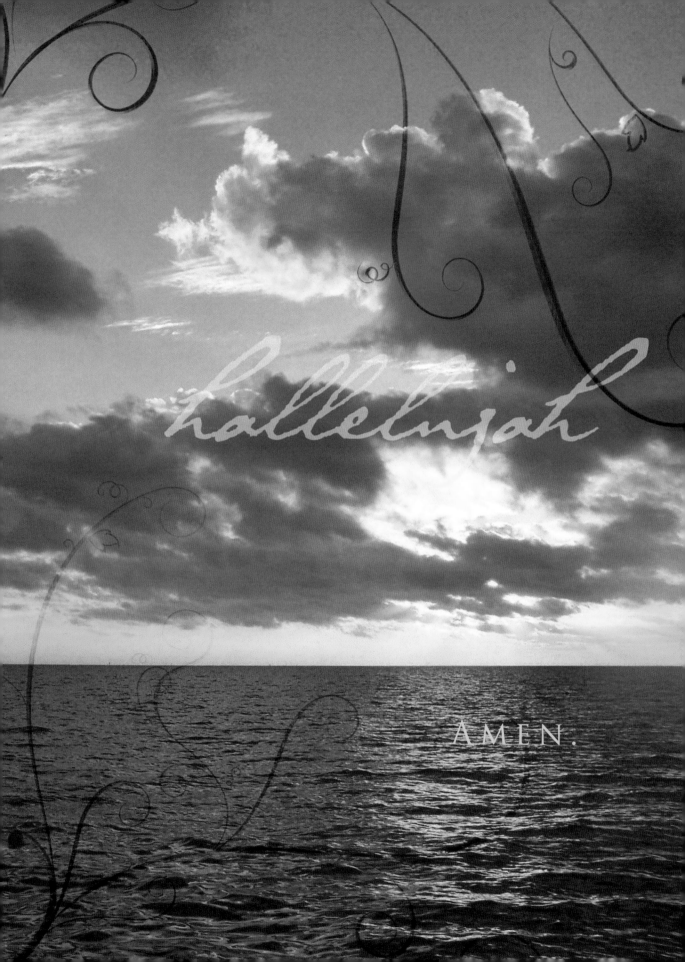

hallelujah

AMEN.

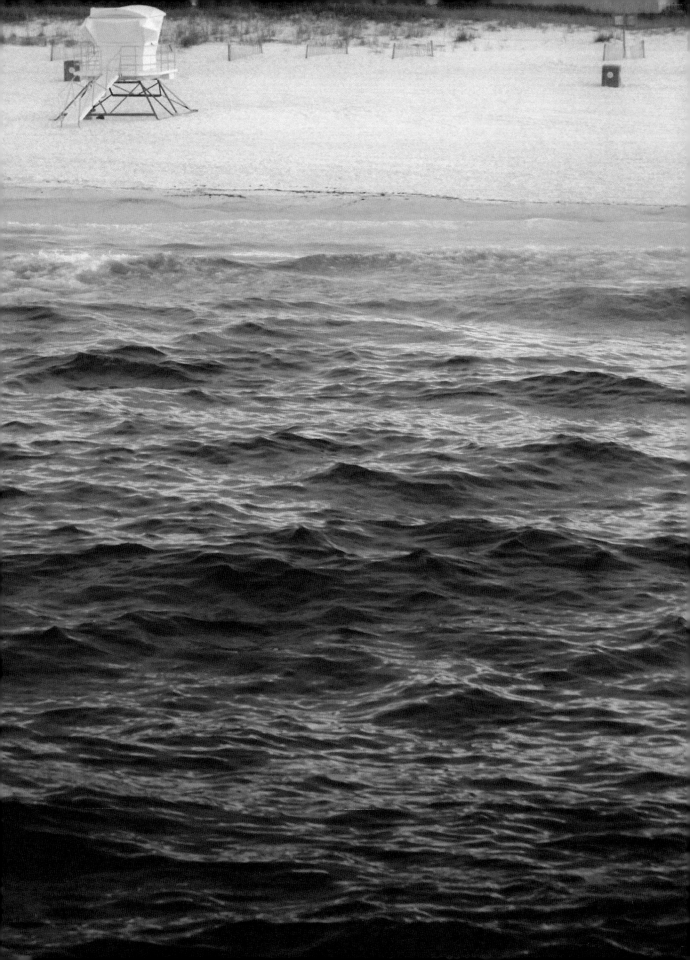

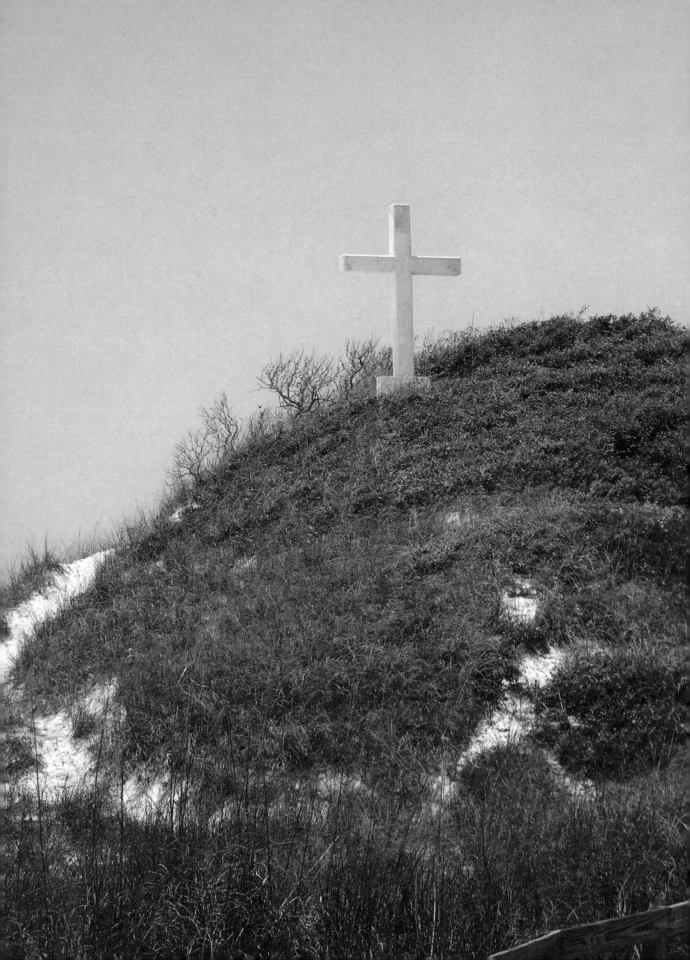

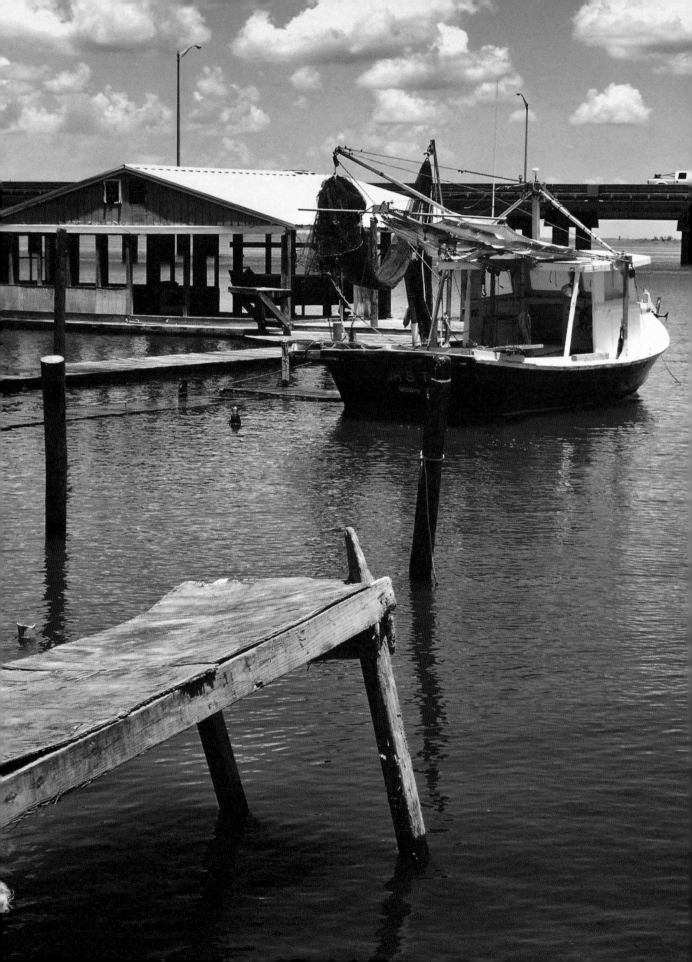

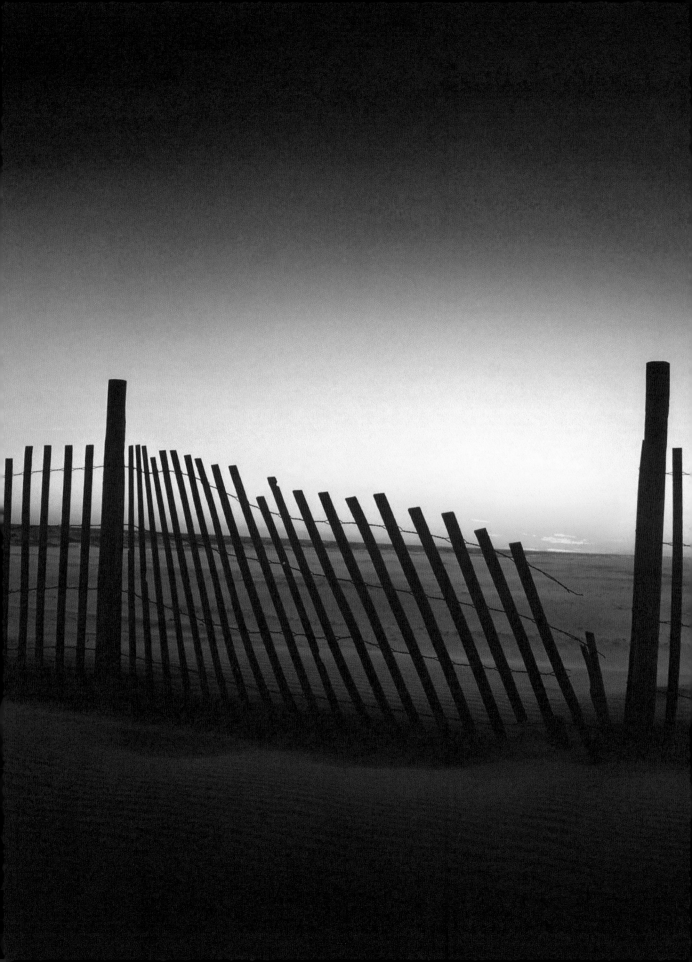

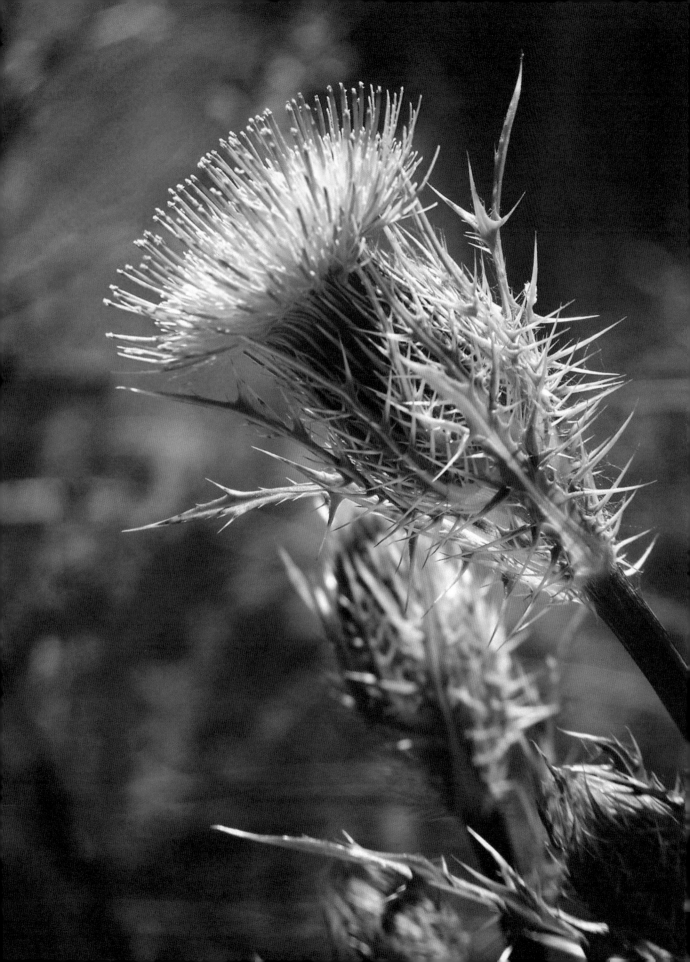

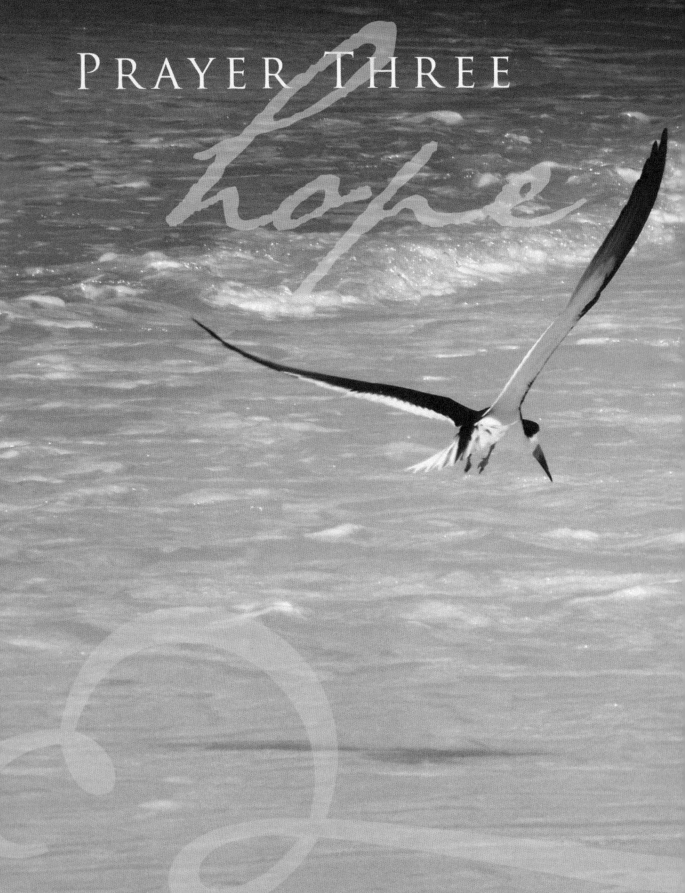

PRAYER THREE

hope

*G*RACIOUS GOD,

WE ARE AMAZED AT YOUR HOPE FOR US...

NO WEAPON FORMED...

NO PLOT CONCEIVED...

NO CATASTROPHE UNVEILED...

CAN TAKE US FROM YOUR CARE.

\mathcal{A}LTHOUGH THE SKY

MAY FILL WITH CLOUDS,

WE ARE NOT AFRAID

OF THE STORM.

THOUGH THE WAVES MAY RISE,

WE ARE NOT AFRAID OF THE SURGE.

Though the shore may fill

with debris, we are not afraid

of the challenge.

Our HOPE is not of this world

but FOR this world...

Because our HOPE is in You.

\mathcal{A}ND, SO, WE WILL FACE THE STORM...

BRACE AGAINST THE SURGE...

CONFRONT THE CHALLENGE...

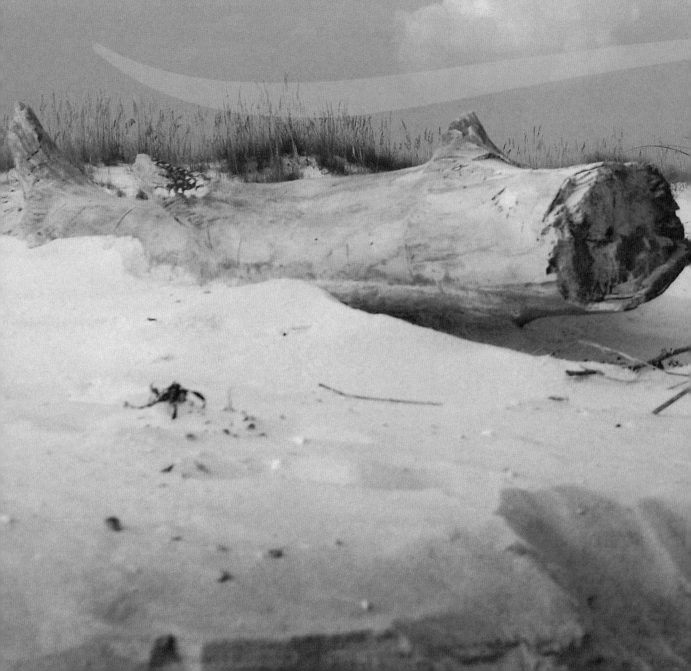

So that for those "whose hands

cannot grasp, whose feet cannot

run, and whose tongues cannot

utter a sound..." (Psalm 93) will find

you a spring that does not run dry.

"O blessed One, Our redeemer,

Our friend, Our HOPE. Amen."

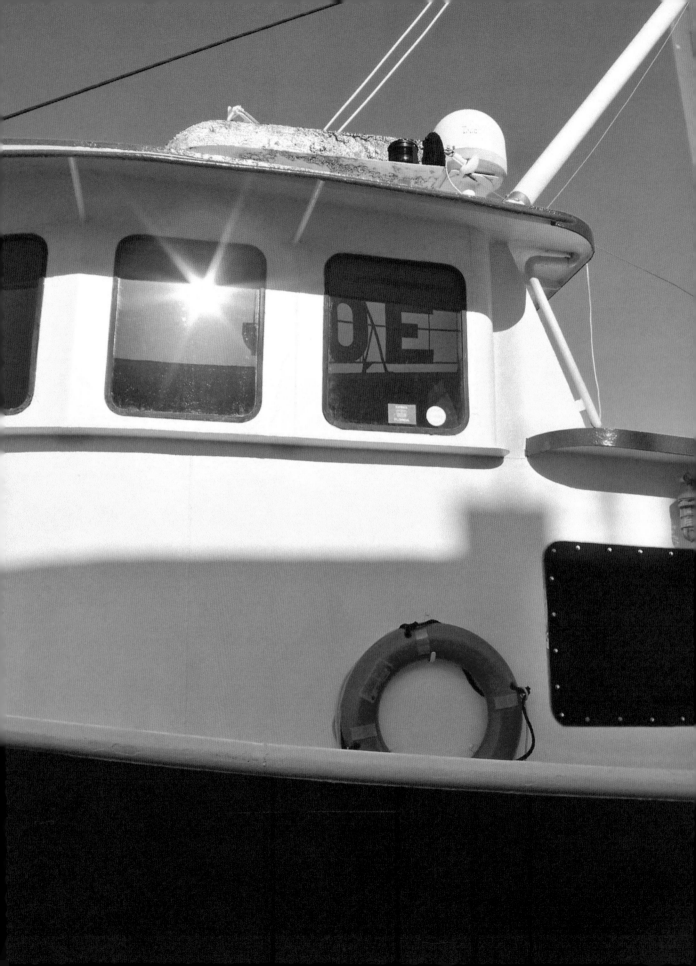

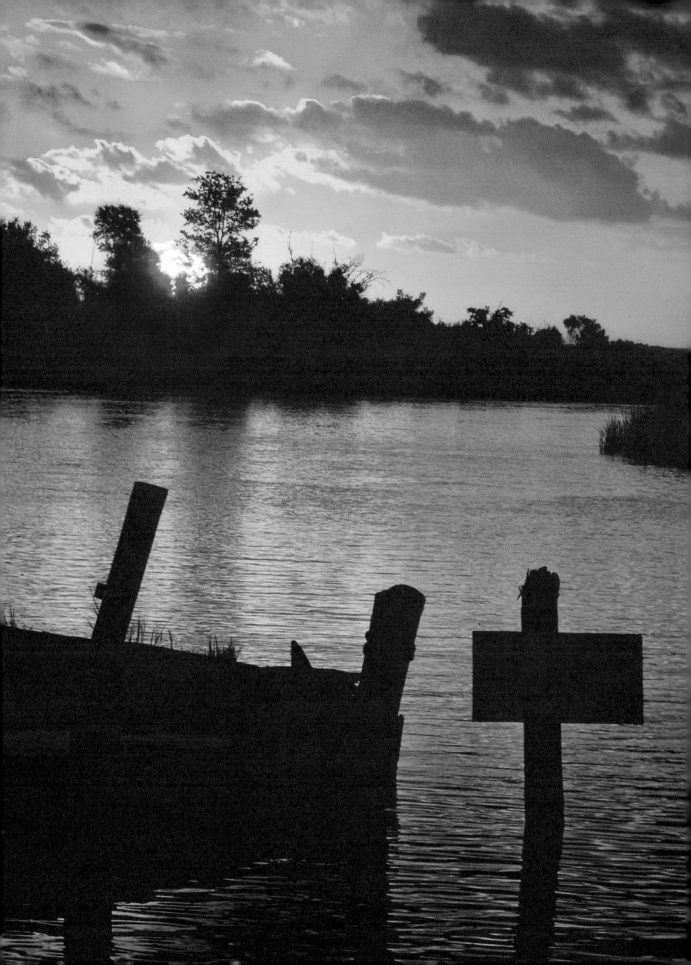

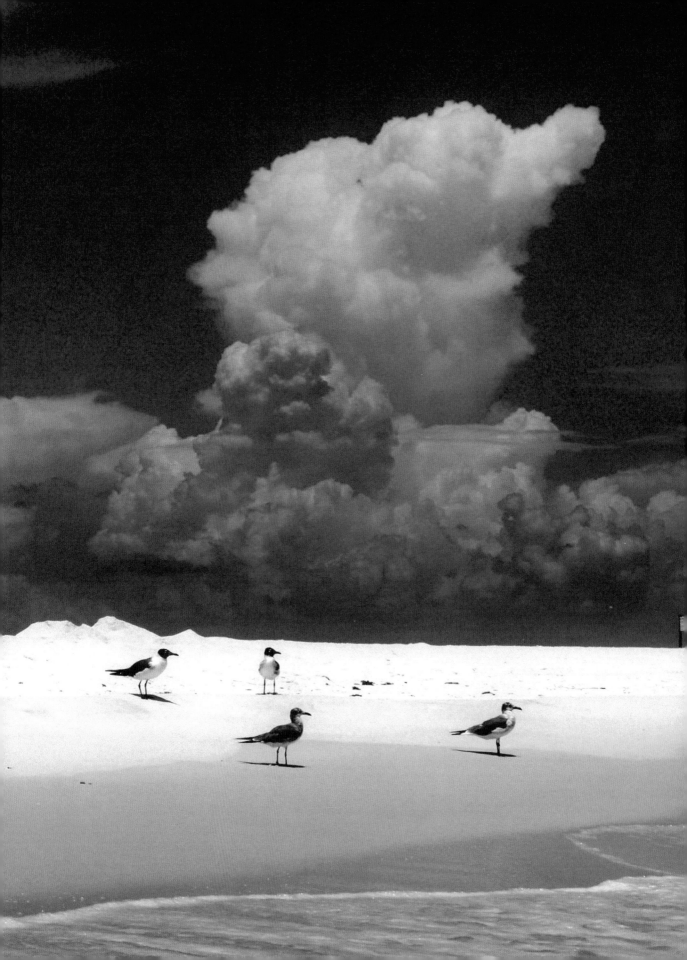

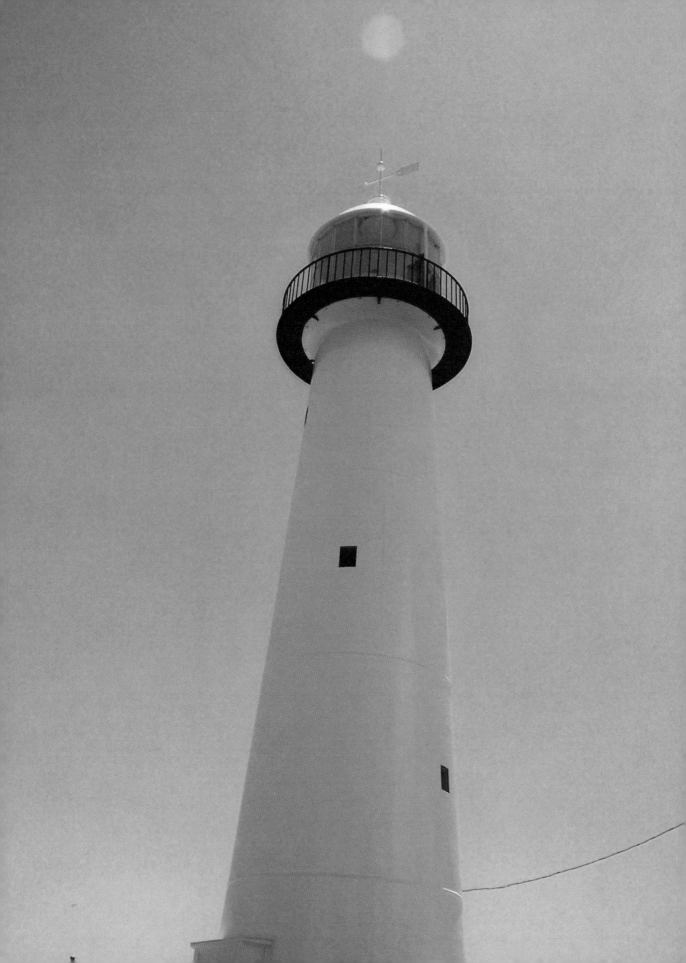

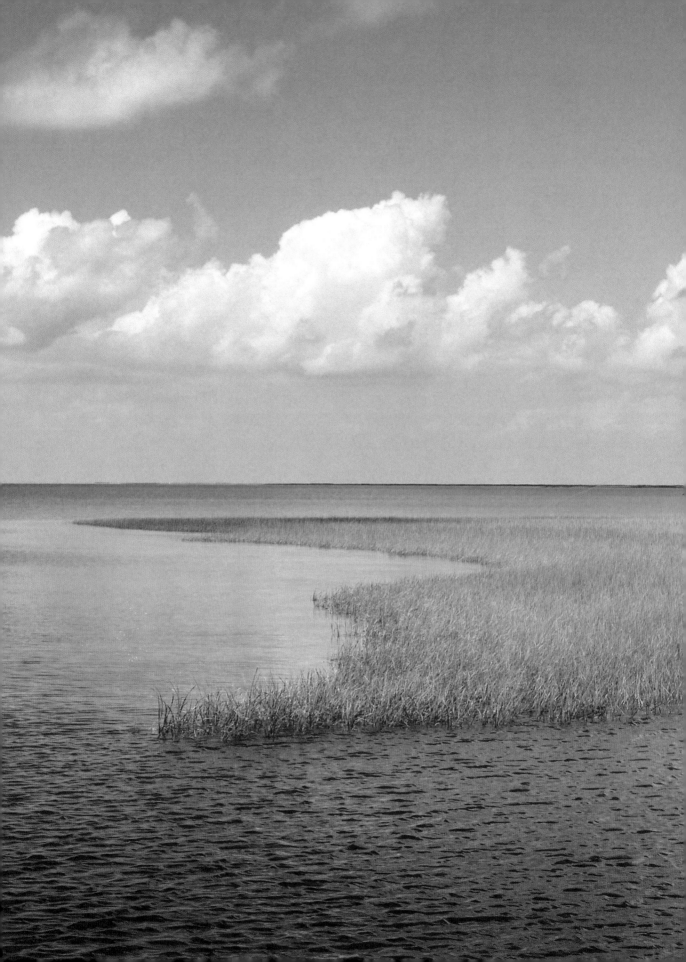

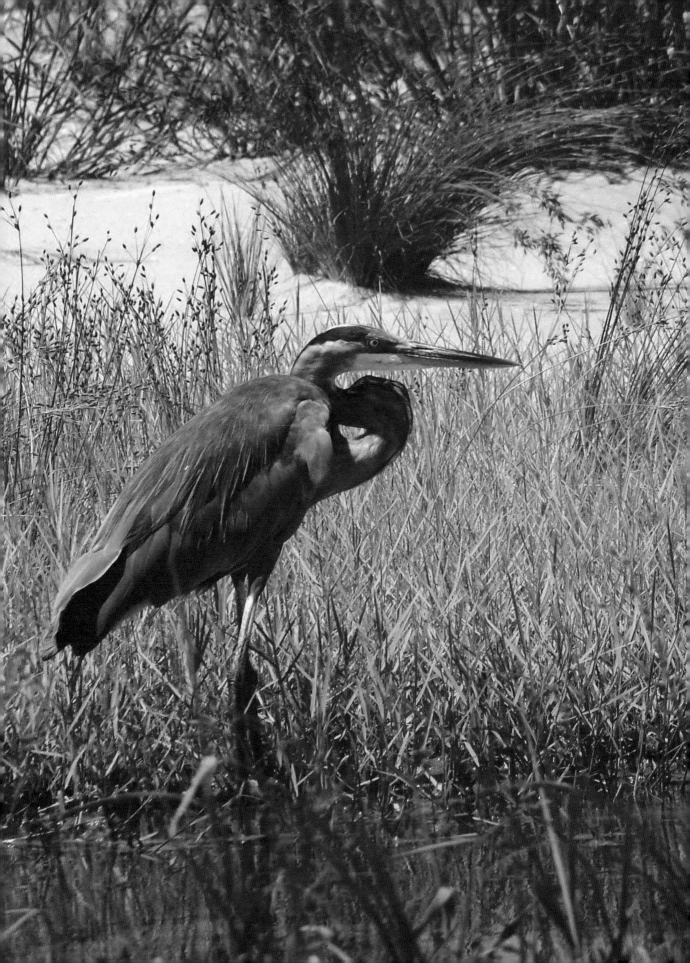

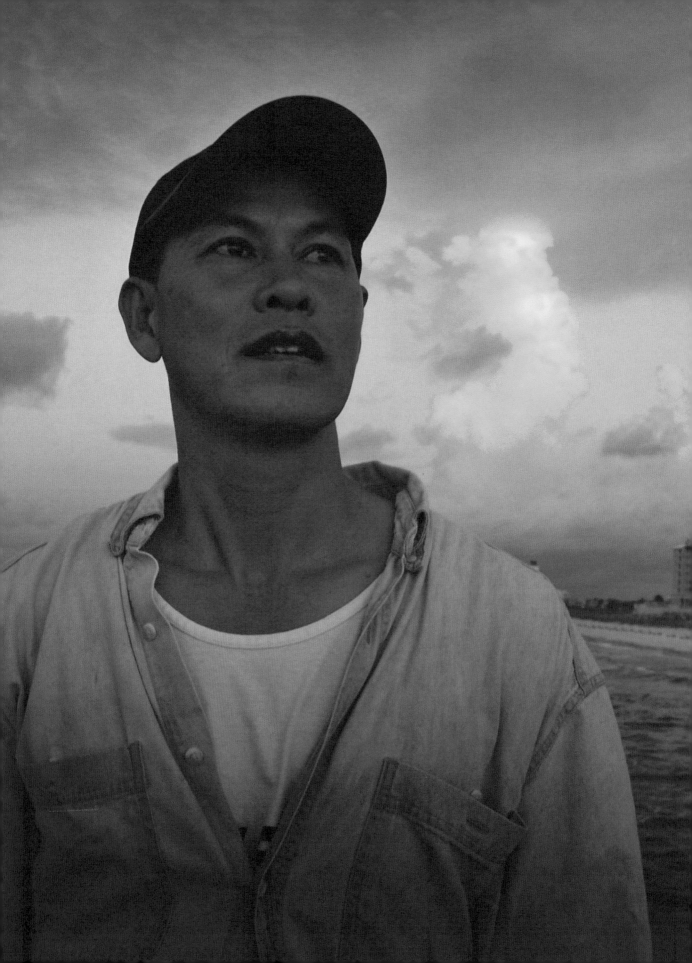

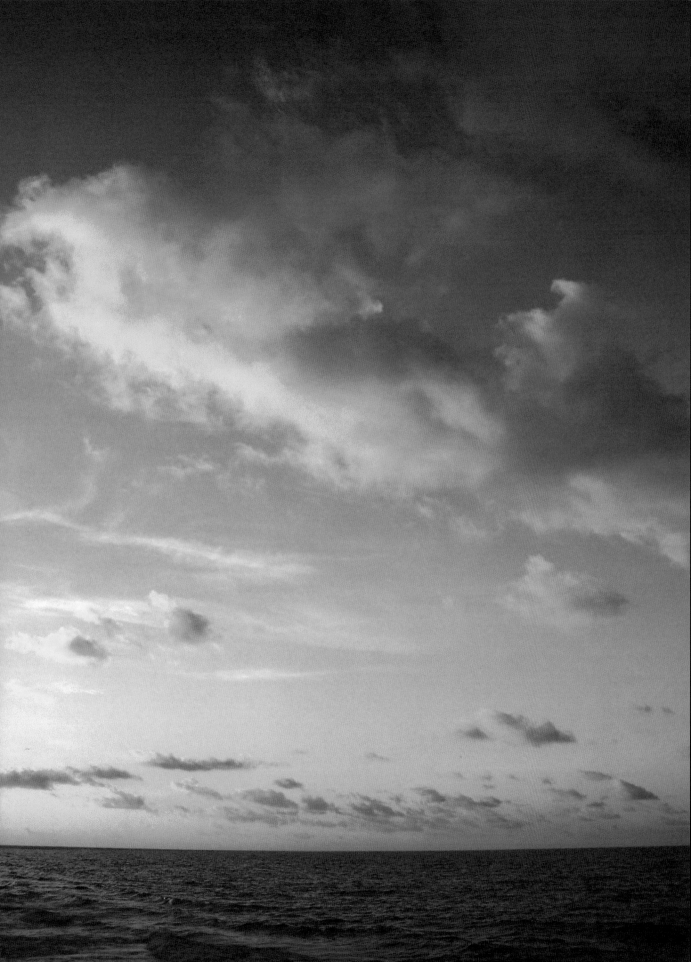

PRAYER FOUR

Gracious God,

We are amazed at Your POWER.

YOU are Creator of all things.

From Your lips came

the Word that SPOKE the

Heavens and the Earth into

existence.

\mathcal{F}ROM YOUR HANDS CAME

THE SEA AND THE LAND THAT

GIVE BIRTH TO ALL CREATURES

EVERYWHERE.

*F*ROM YOUR EYES CAME THE

VIBRANT COLORS OF SPRING

AND THE SKEW OF THE SEASONS

THAT REMIND US OF A WORLD

VERY MUCH ALIVE.

\mathcal{A}ND, FROM YOUR HEART, CAME

THE POSSIBILITIES FROM

WHICH EVERY SUNRISE TAKES

SHAPE, AND EVERY SUNSET

TAKES HOLD.

CREATION IS MORE THAN THE

SUM OF WHAT YOU CAN SAY...

BUT YOU SPOKE INTO IT ANYWAY...

AND YOUR **POWER** PUNCTUATES

EACH LINE.

\mathcal{A}nd, thus, there is no part of ETERNITY that does not appear in Your HERE and NOW.

FOR EVEN **TIME** RIDES

THE EDGES OF YOUR ROBE; AND

MEANING SPANS THE

CORNERS OF YOUR STOLE.

YOU ARE

EVERYTHING...

EVERYTHING...

EVERYTHING... AND MORE.

AMEN.

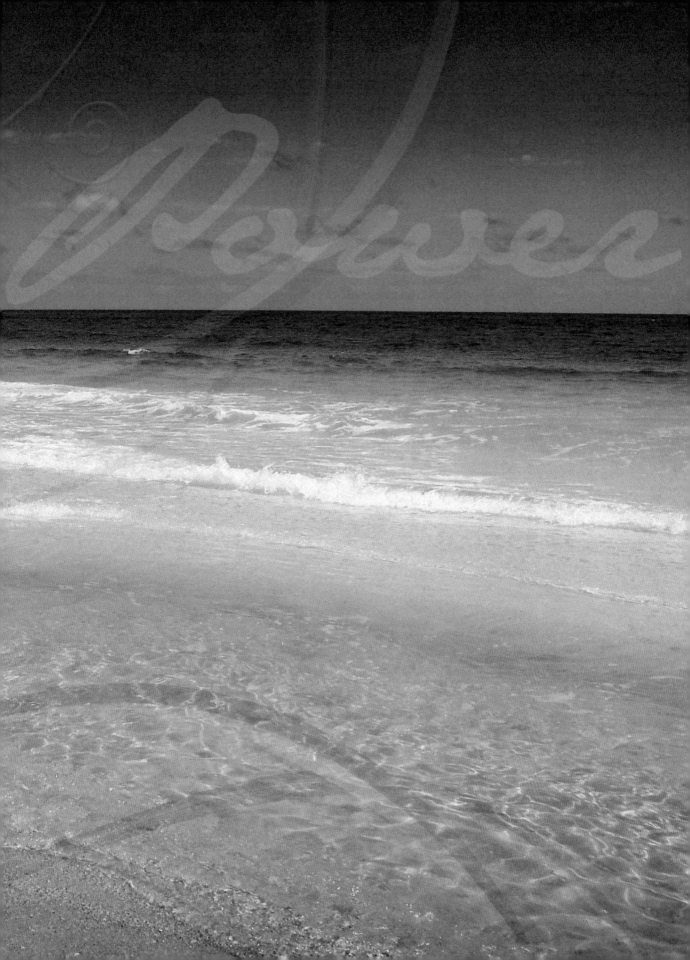

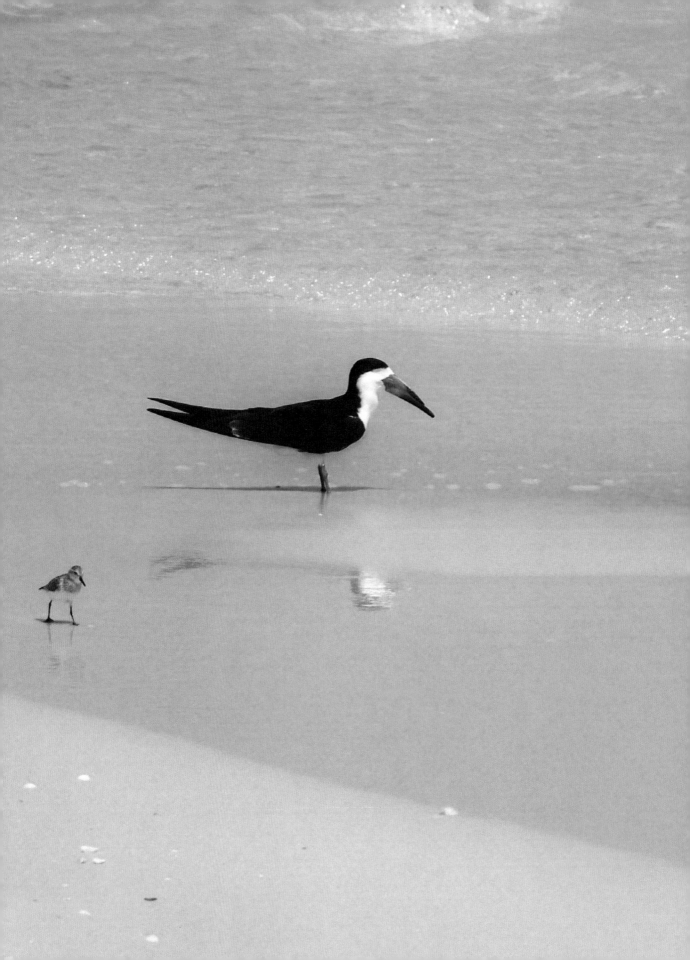

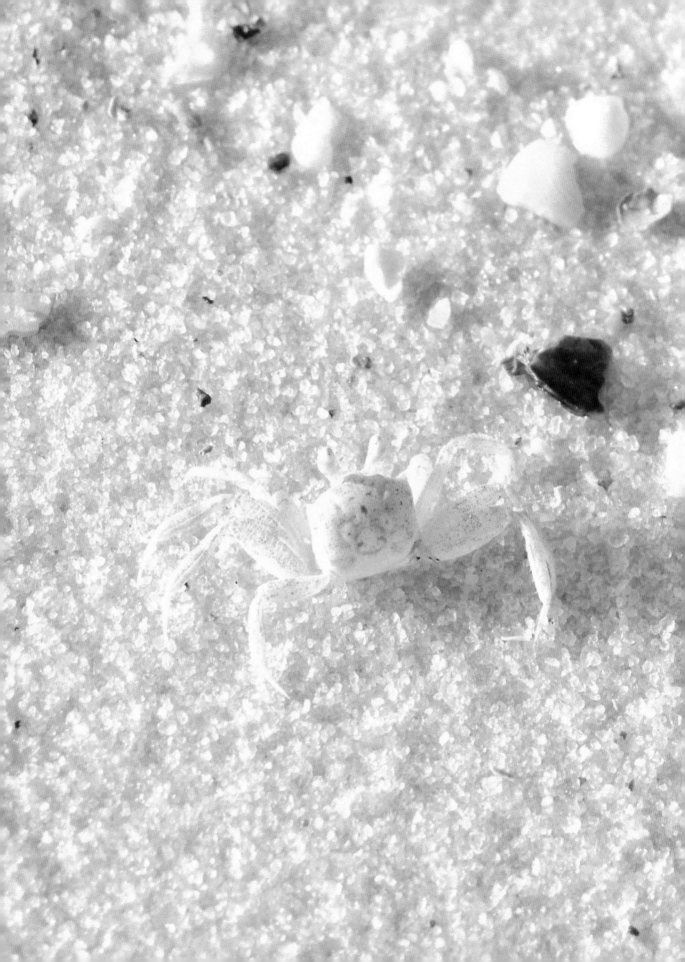

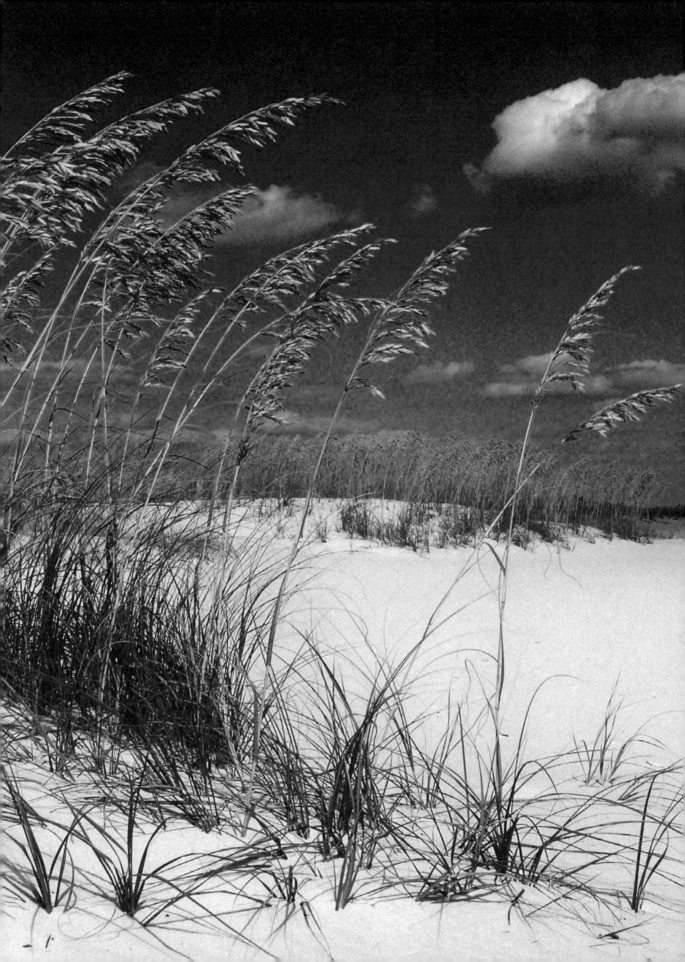

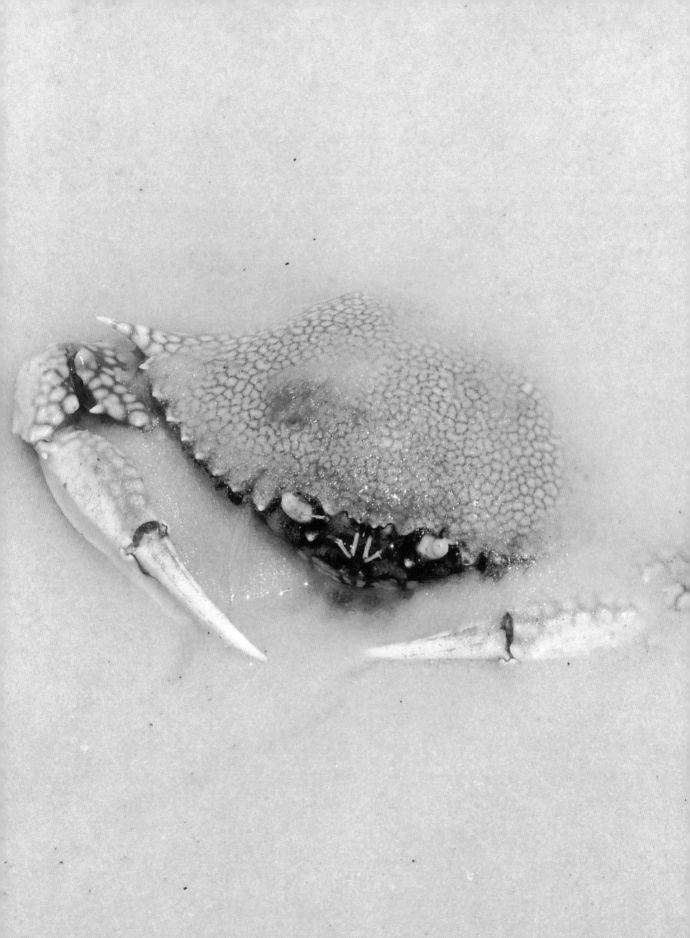

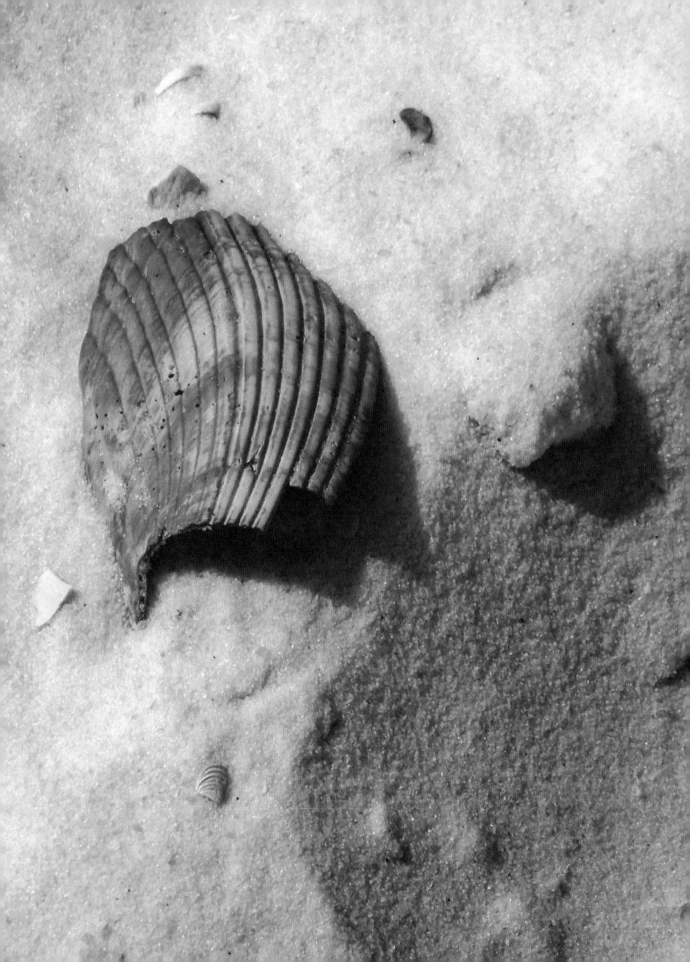

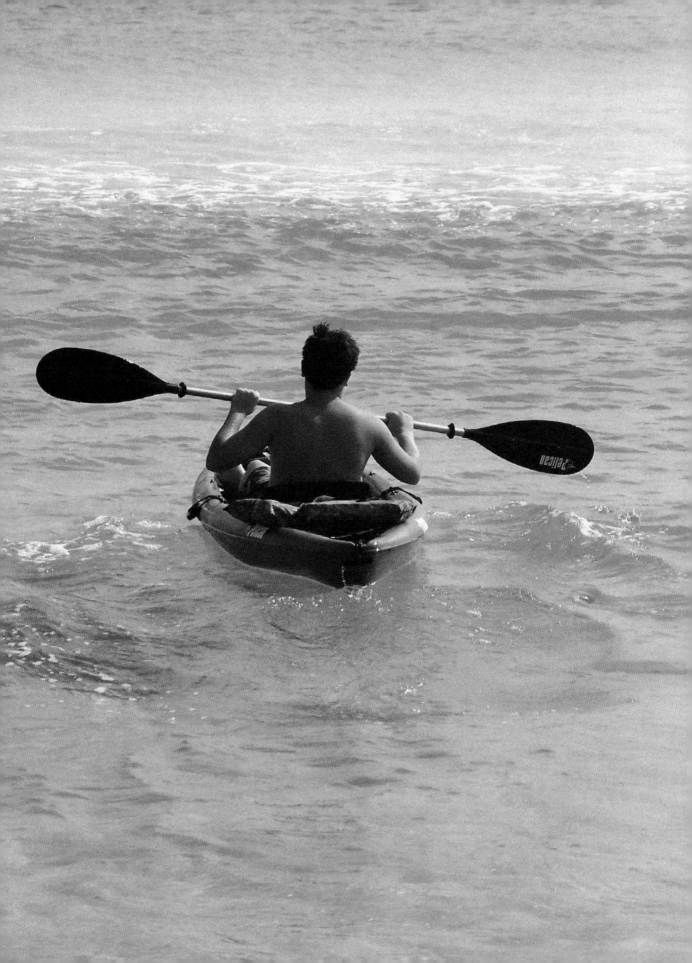

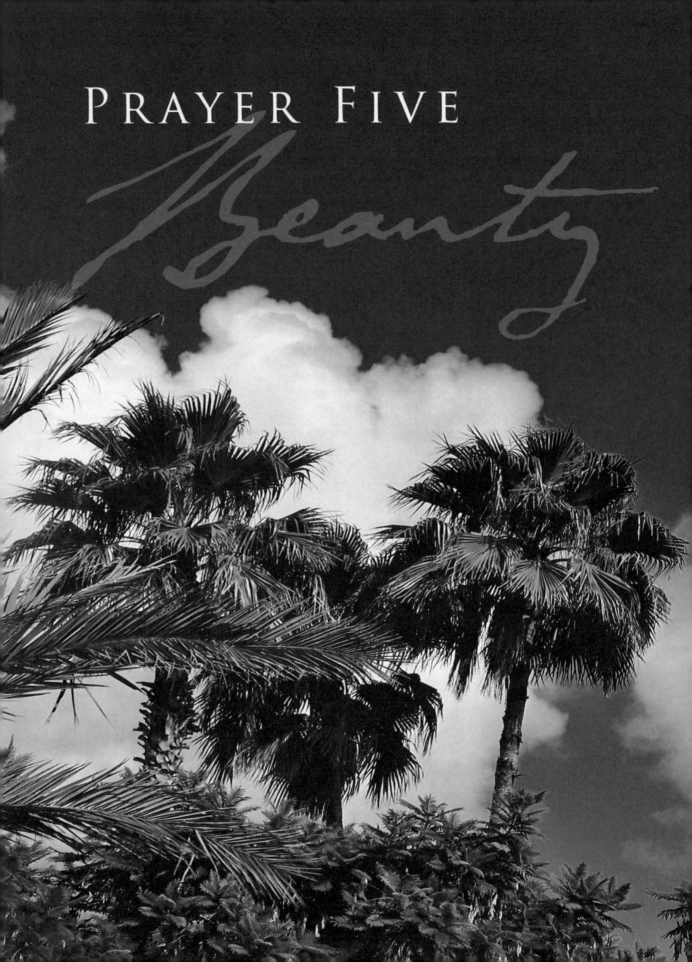

PRAYER FIVE

Beauty

GRACIOUS GOD,

WE ARE AMAZED AT THE BEAUTY

OF YOUR CREATION.

THE COLORS OF LIFE ARE MORE

EXQUISITE THAN AN ARTIST'S PALETTE.

THE SKY IS A SOFT BLUE.

THE EARTH A MIX OF RICH

GREENS, BROWNS

AND REDS.

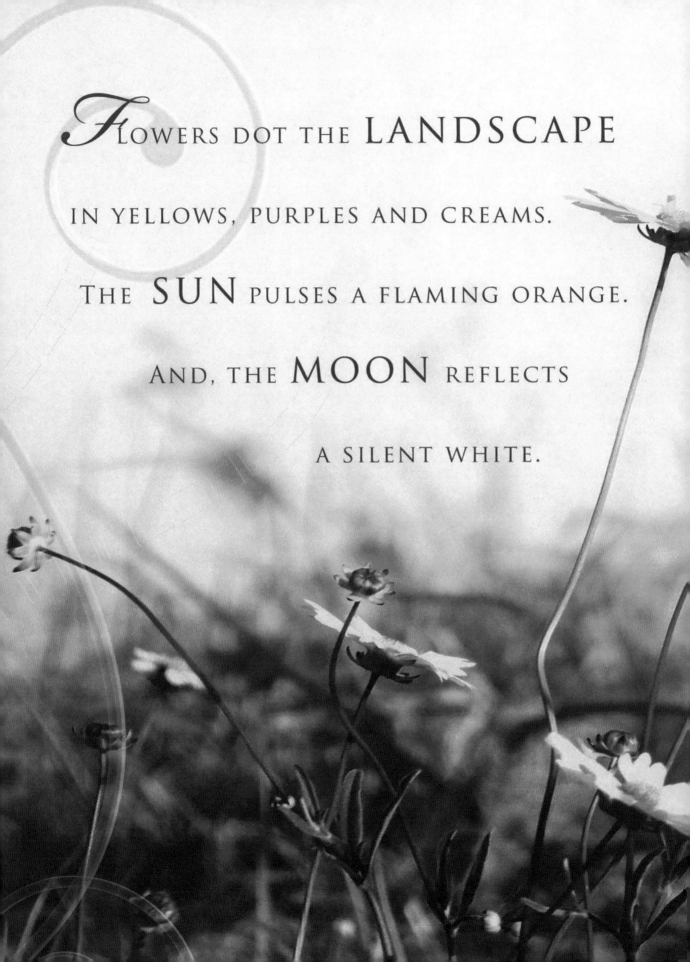

\mathcal{F}LOWERS DOT THE **LANDSCAPE**

IN YELLOWS, PURPLES AND CREAMS.

THE **SUN** PULSES A FLAMING ORANGE.

AND, THE **MOON** REFLECTS

A SILENT WHITE.

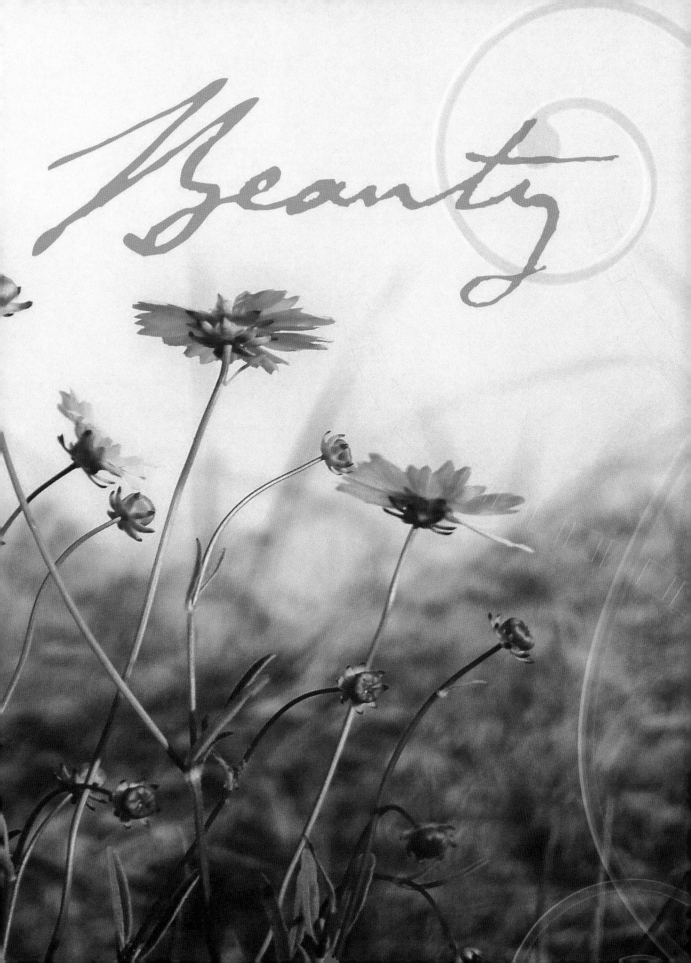

THE BOUNDARIES OF EARTH

SPARKLE AGAINST THE PROFOUND

BLACK OF SPACE... SPRINKLED WITH

THE ENERGY OF PLANETS, STARS

AND MOONS.

THE OUTFLOW OF THE UNIVERSE

CANNOT BE CONTAINED AS IT RACES

FROM ITS EXPLOSIVE CENTER

TO THE FAR REACHES

OF UNKNOWN TIME.

AND, YET, WITH GALACTIC SCENES

ECHOING THROUGHOUT OUR

CONSCIOUSNESS...

A SIMPLE FLOWER BLOOMS---

A SEED FALLS TO EARTH

A BIRD CHIRPS ITS SONG---

A breeze chimes the melody---

That from the edges of

GALAXIES to the touch of the

sand--- the canvas of Your

CREATION comes to life in

a billion ways... and, then,

in a BILLION more.

Beauty

Oh, if but one eye could capture

the breadth, width, depth, or height

of such beauty... But, for now, until

that day--- from Head to Toe, from

Heaven to Earth, from

sunrise to sunset (Psalm 103)---

we look to You, through You,

for you. And, we are content.

Amen.

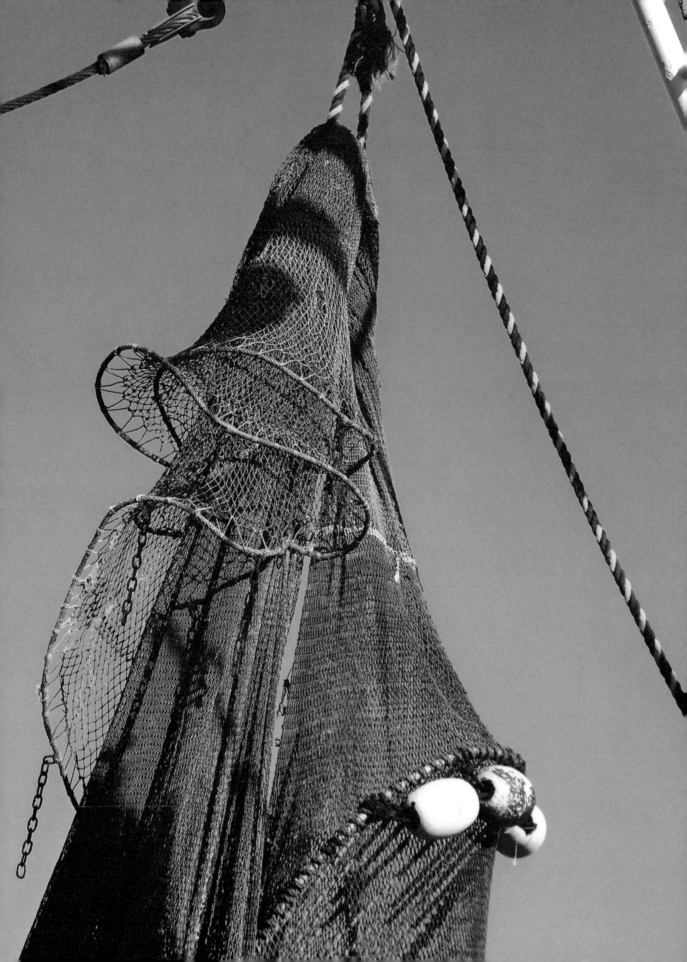

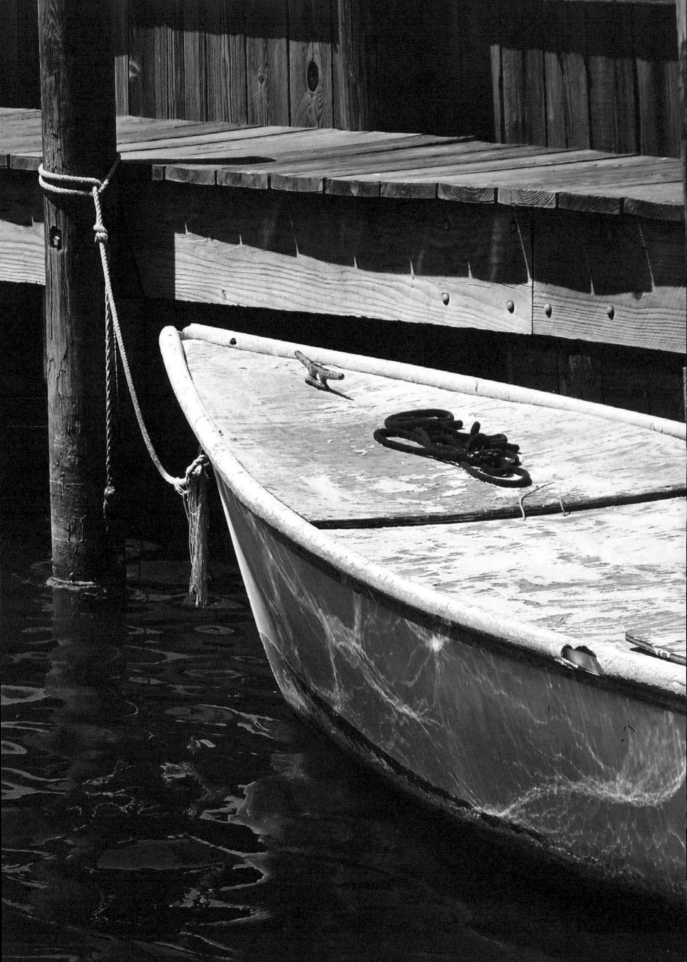

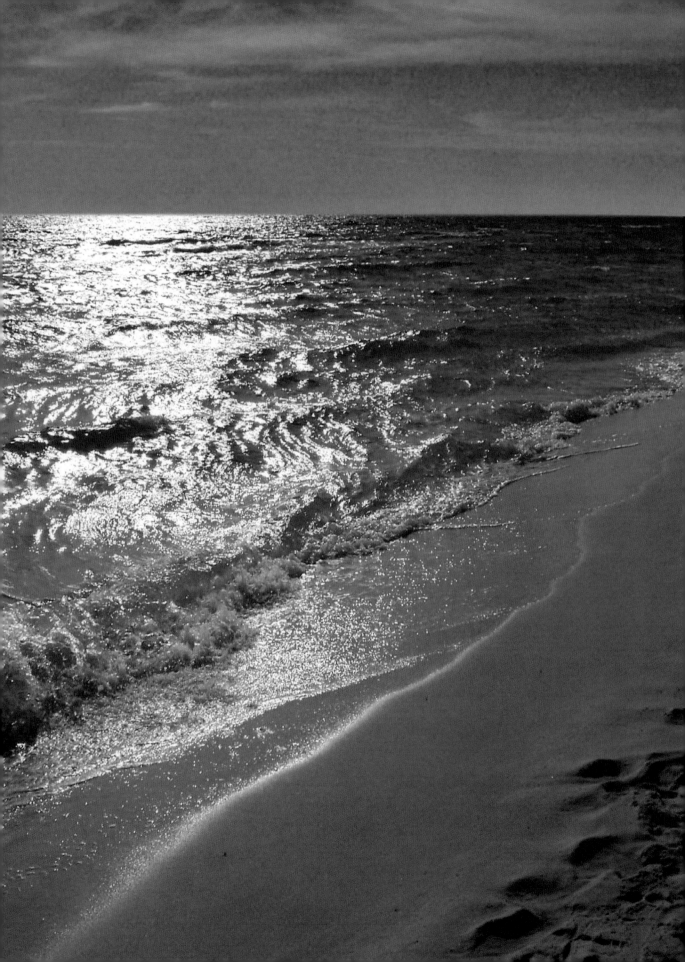

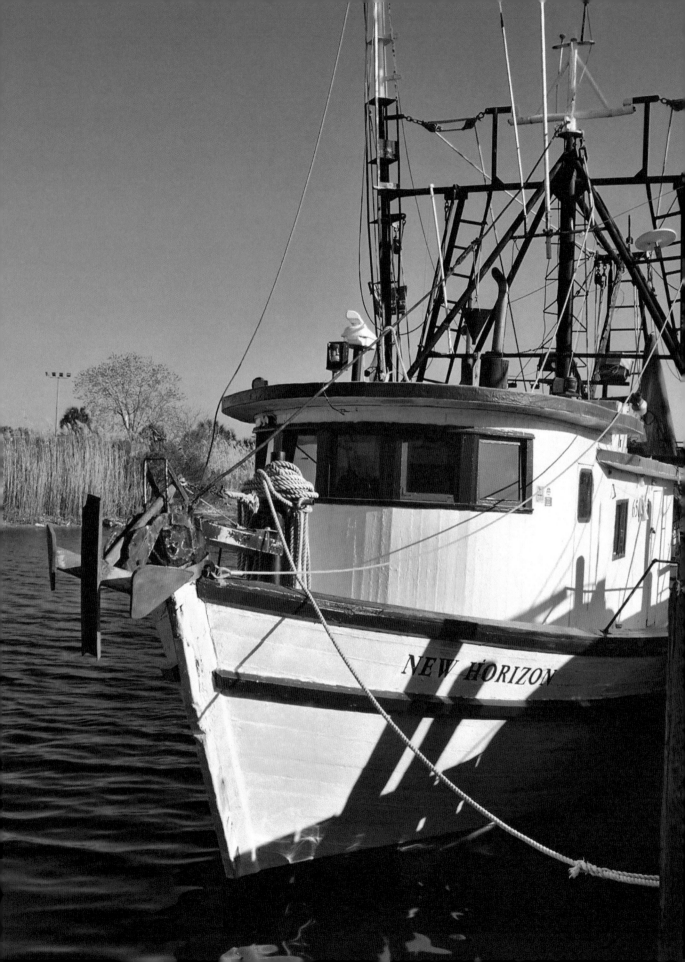

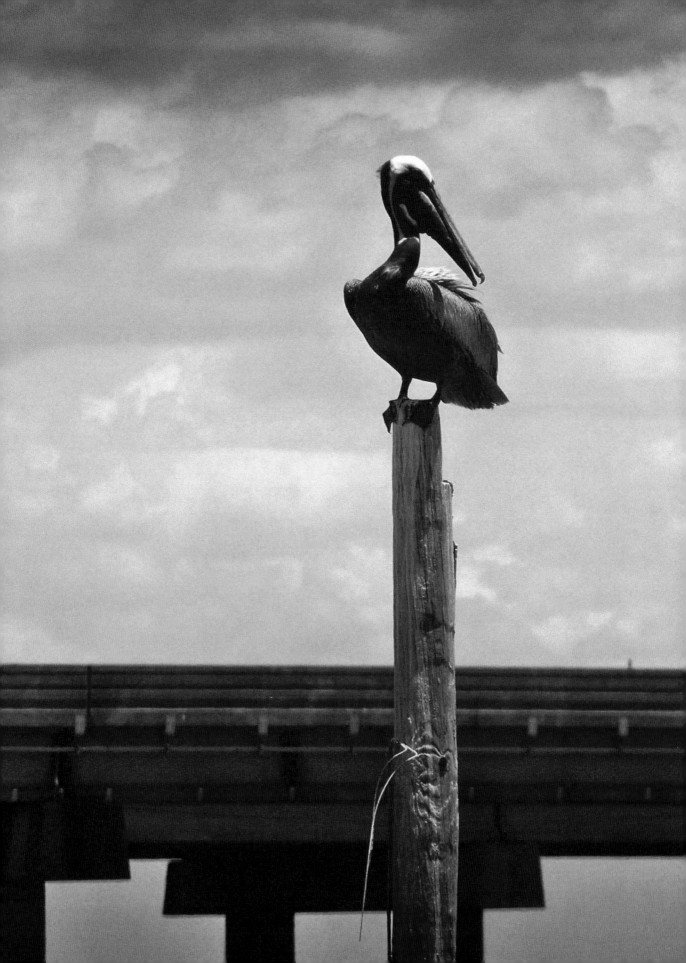

PRAYER SIX

Gracious God,

We are amazed at the possibilities

within your CREATION.

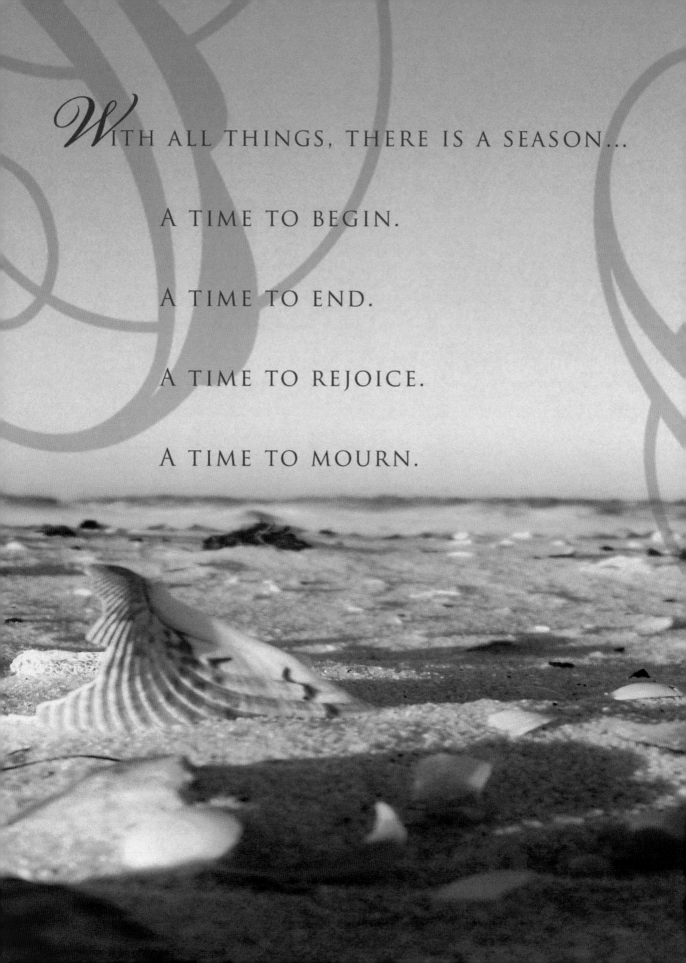

WITH ALL THINGS, THERE IS A SEASON...

A TIME TO BEGIN.

A TIME TO END.

A TIME TO REJOICE.

A TIME TO MOURN.

CREATION IS THE ANCHOR

TO THE PULSE OF TIME.

YOU LAID INFINITY WITHIN OUR

HANDS AND GAVE ETERNITY AS

A GLIMPSE FOR OUR EYES.

WE ARE BOUND TO EVERY DAY, THE WAY

BROTHERS ARE CONNECTED BY HEART.

THERE IS NO SEPARATING THE

POTENTIAL OF ONE

FROM THE

REALITY

OF THE

OTHER.

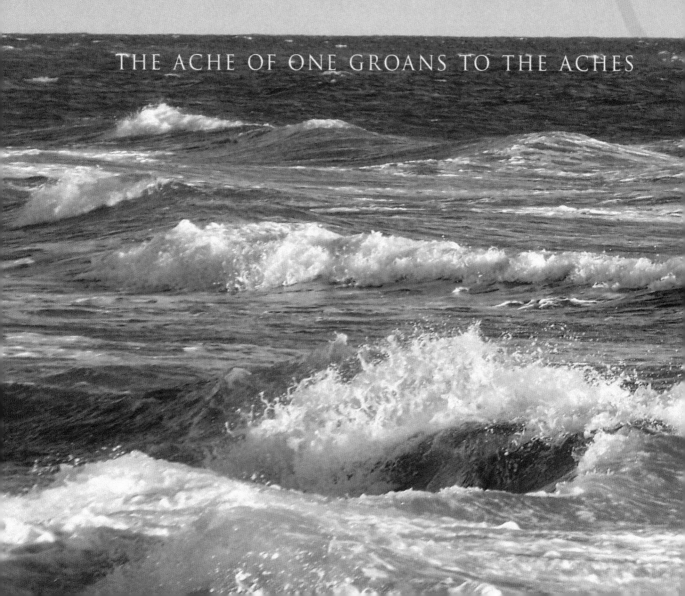

*S*UCH BONDS ARE A GIFT BECAUSE

THEY SPEAK TO MORE THAN FAMILIARITY

BUT TO FAMILY. THE DESIRES OF ONE

POINTS TO THE DESIRES OF THE OTHER.

THE ACHE OF ONE GROANS TO THE ACHES

OF THE OTHER. AND THE BURDENS OF ONE,

WEEPS FOR THE BURDENS OF... US ALL.

WE ARE NO MORE AND NO LESS THAN WHAT

WE CHOOSE TO BE... TOGETHER.

\mathcal{B}UT, THE TAPESTRY HAS ANOTHER SIDE.

THE SONG ANOTHER VERSE.

THE SONNET ANOTHER STANZA.

THE STORY ANOTHER PAGE.

FOR WHERE THERE IS HOPE FOR ONE,

THERE IS HOPE FOR ALL.

WHERE THERE IS JOY FOR ONE, THERE

JOY FOR ALL.

WHERE THERE IS SIGNIFICANCE FOR ONE,

ALL OF US FIND OUR WAY.

\mathcal{A}ND, WHERE THERE ARE POSSIBILITIES

FOR ANY OF US, CREATION UNFOLDS

FOR YOUR GLORY.

WE MUST WAKE UP AND SEE

FOR OURSELVES.

YOU ARE ON THE JOB.

AND ALL THINGS ARE POSSIBLE.

AMEN.

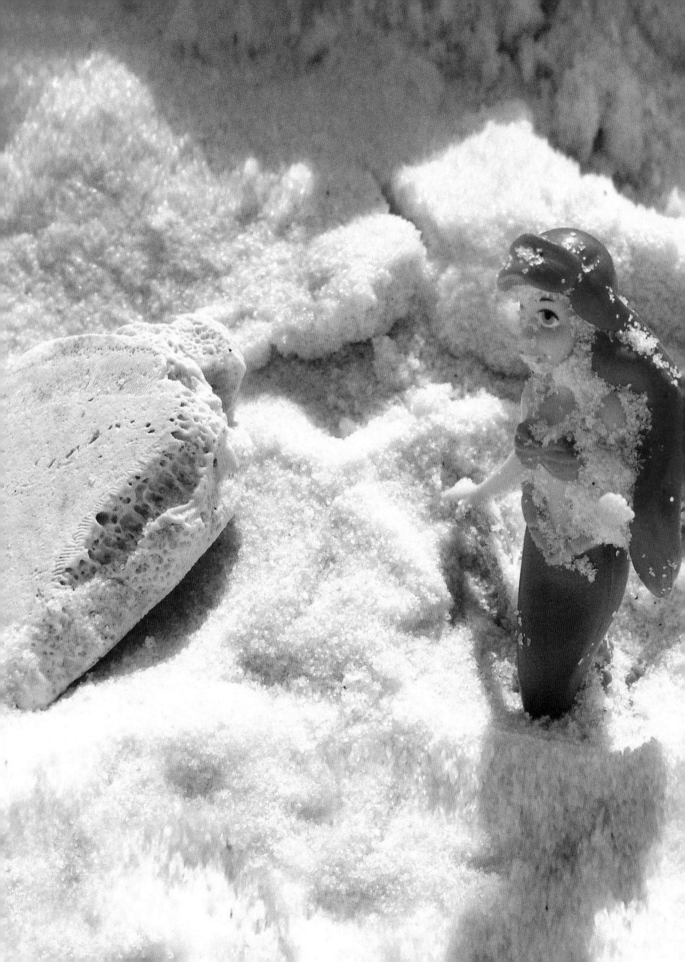

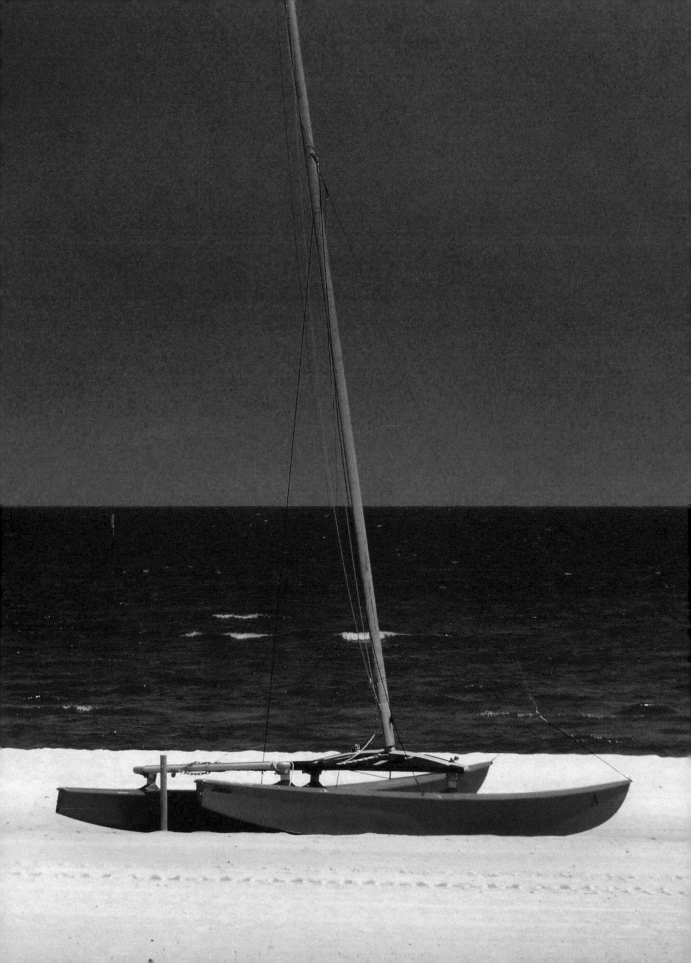

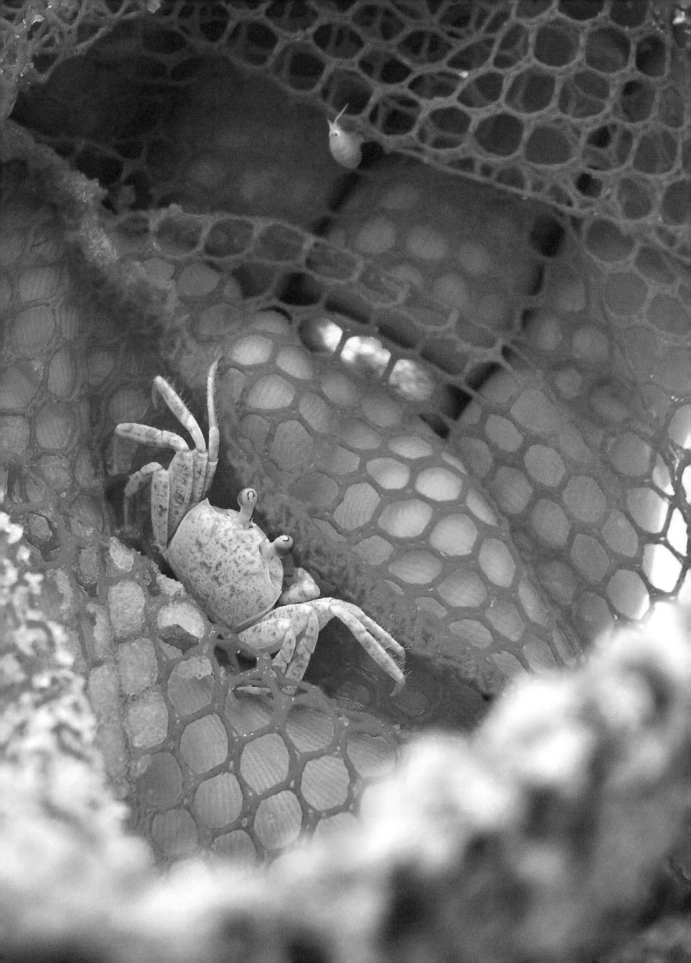

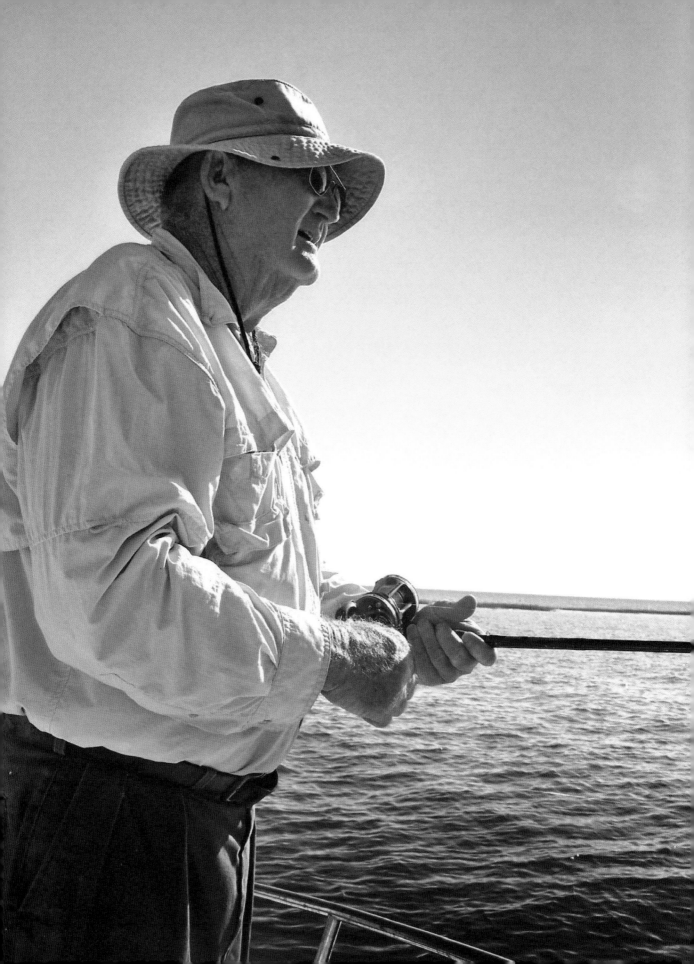

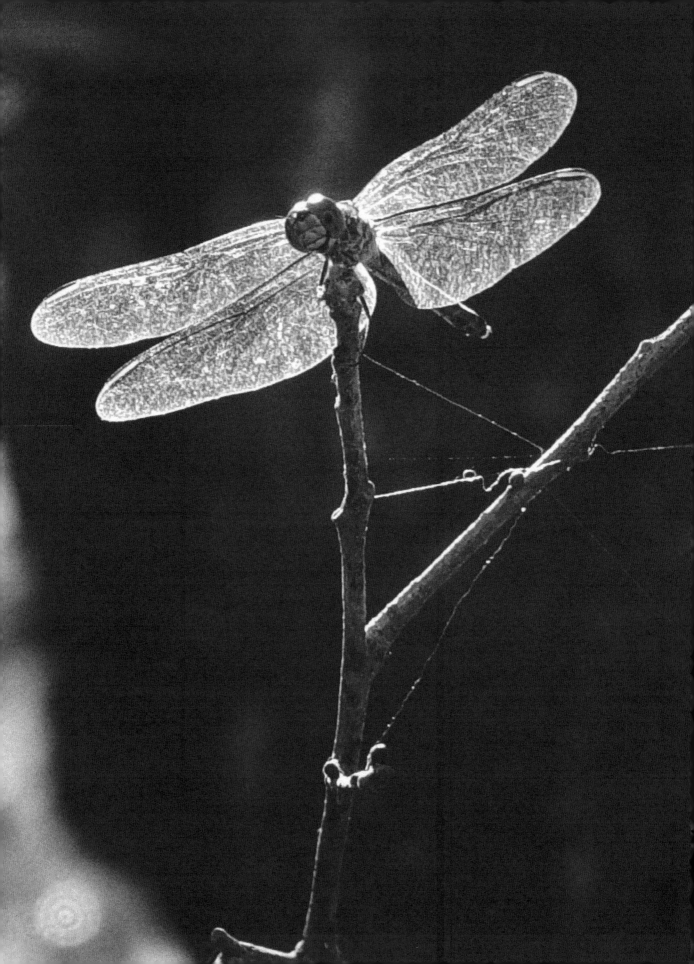

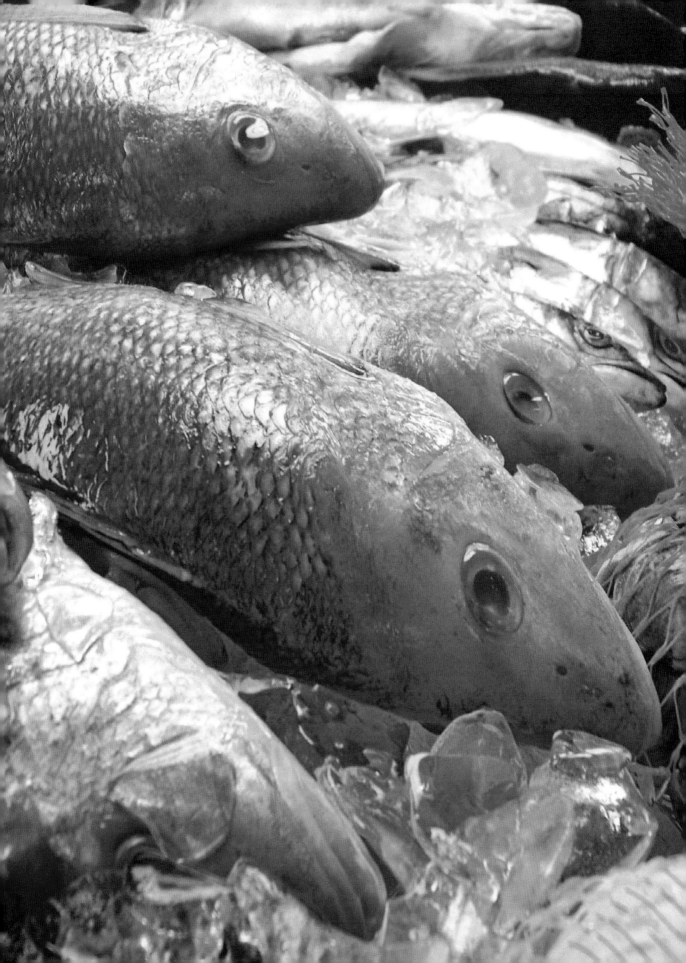

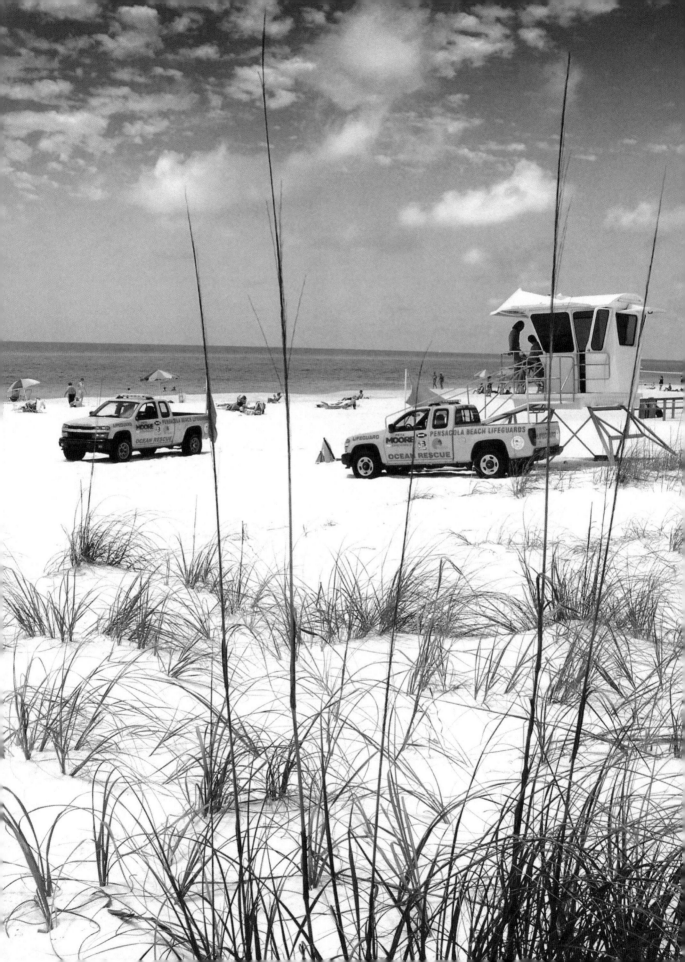

PRAYER SEVEN

resilience

Gracious God,

We are amazed at the Resilience

of Your creation.

Some may ask---

How many stumbles before we fall?

How many tears before we fail?

How many broken hearts before we forsake?

AND, YET, EACH DAY BRINGS YOU

BACK TO US--- THOUGH YOU NEVER LEAVE.

EACH WHISPER REMINDS YOU OF YOUR LOVE

FOR US--- THOUGH YOU NEVER FORGET.

EACH SUNSET PUTS US BACK INTO YOUR

CARE--- THOUGH YOU NEVER ABANDON.

WE ARE YOURS, AND YOU ARE OURS.

For one more smile.

One more laugh.

One more song.

One more prayer.

One more sacrifice.

One more moment... with You.

We are not alone, You are always near.

Hallelujah.

\mathcal{P}RAISE FOR ALL WE GET RIGHT.

PRAISE FOR ALL WE MAKE RIGHT.

PRAISE FOR ALL WE LEAVE RIGHT.

WE ARE NOT AFRAID, YOU ARE WITH US.

SHOUT FOR JOY.

May we never forget who

pushed back the sea.

May we never miss who lit the sky.

May we never ignore who

softened the night.

For every tear, there is a SMILE.

For every fear, there is a HOPE.

For every night, there is a NEW DAY.

And, for every wound, there is

a BALM that nurtures us and

makes us whole.

Truly, if You are for us...

Well...

That is enough.

So be it.

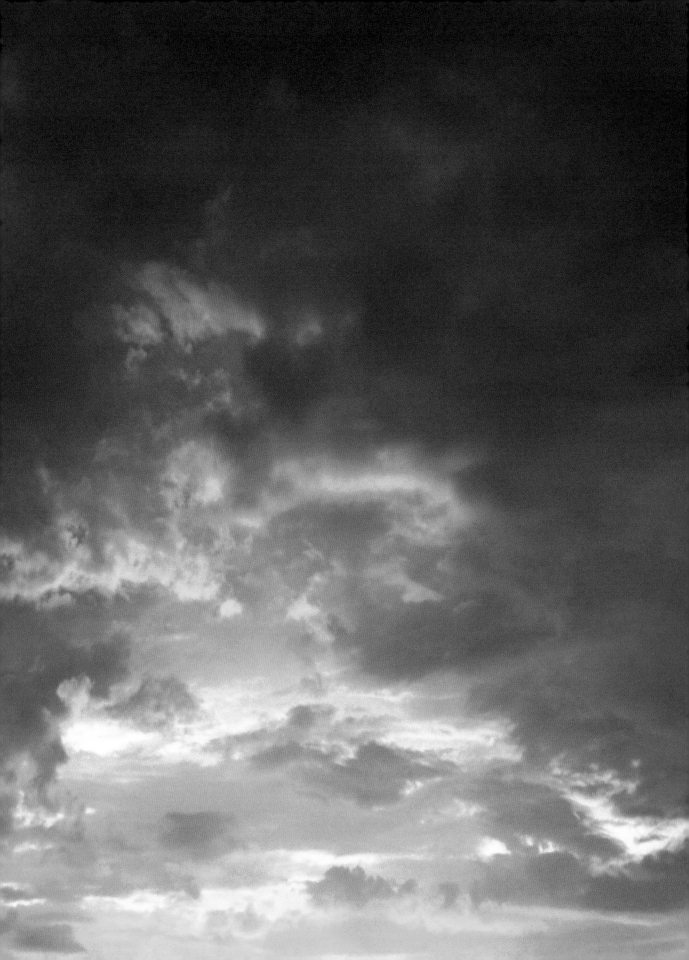

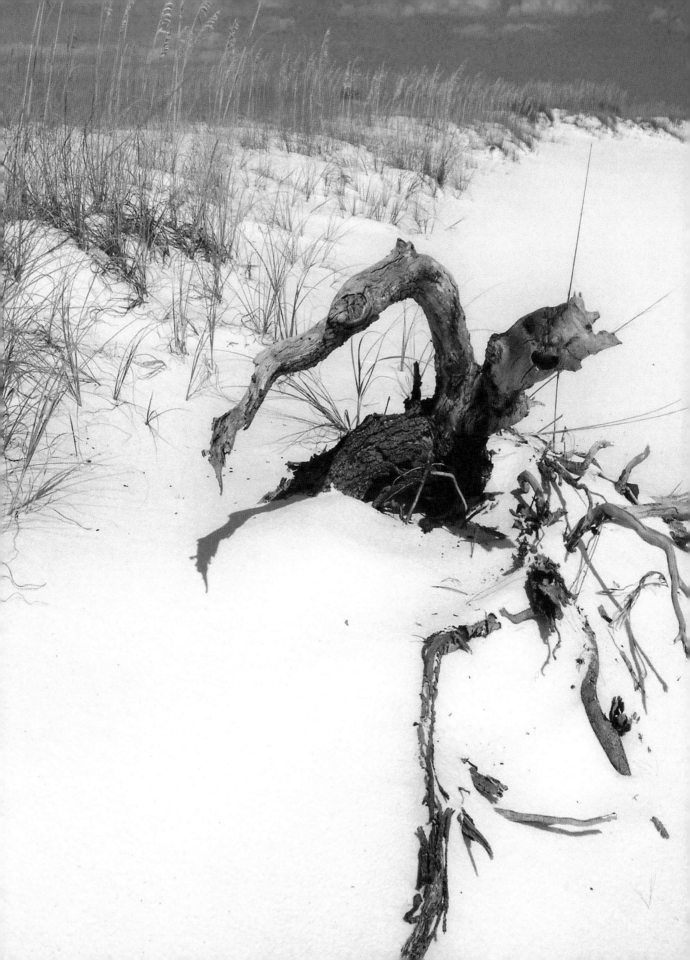

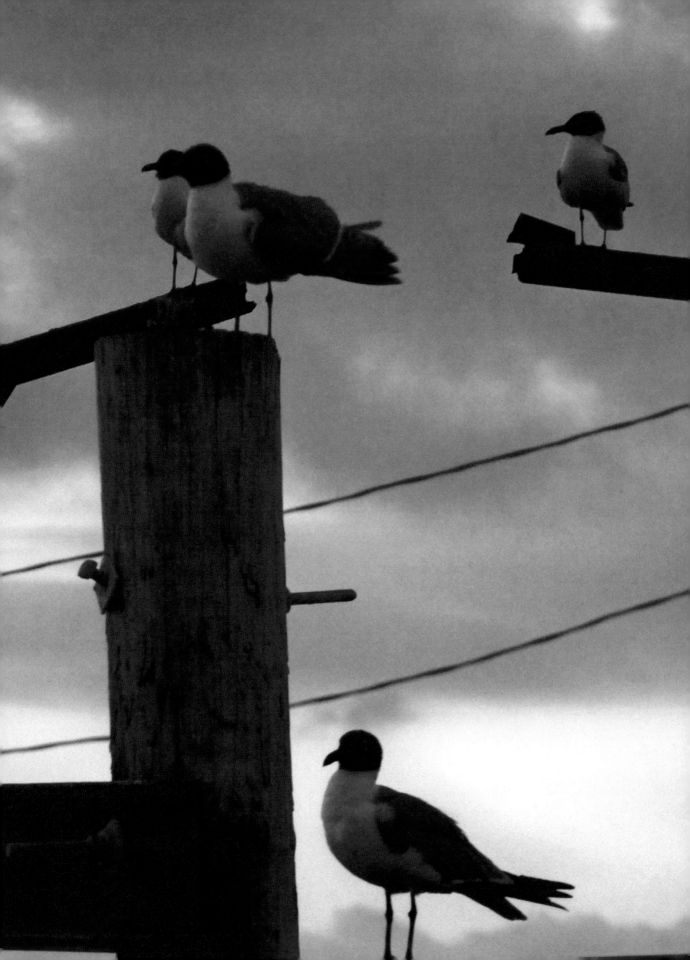

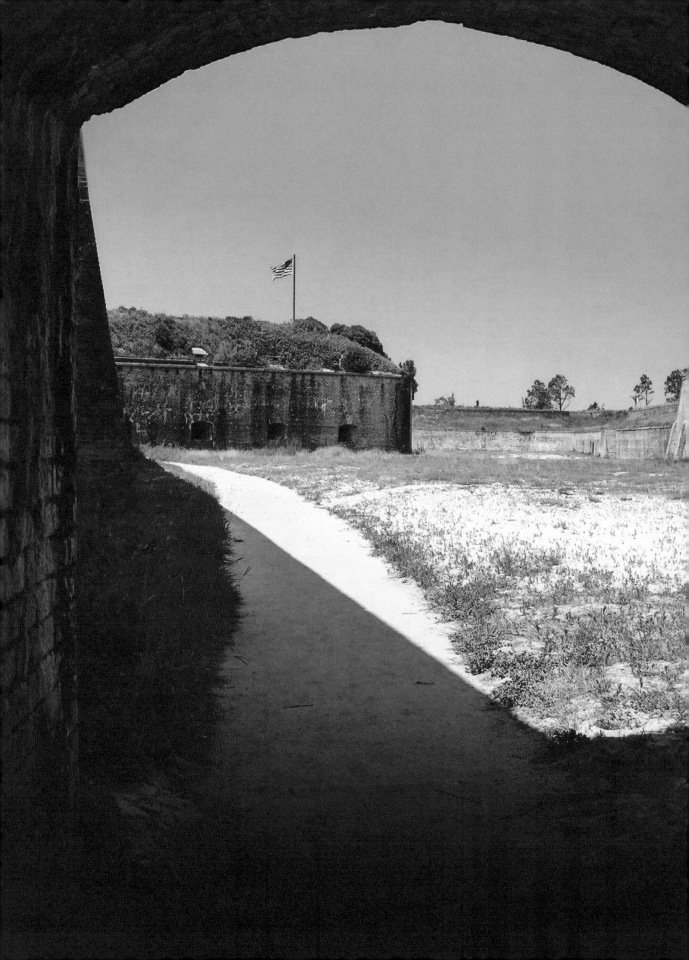

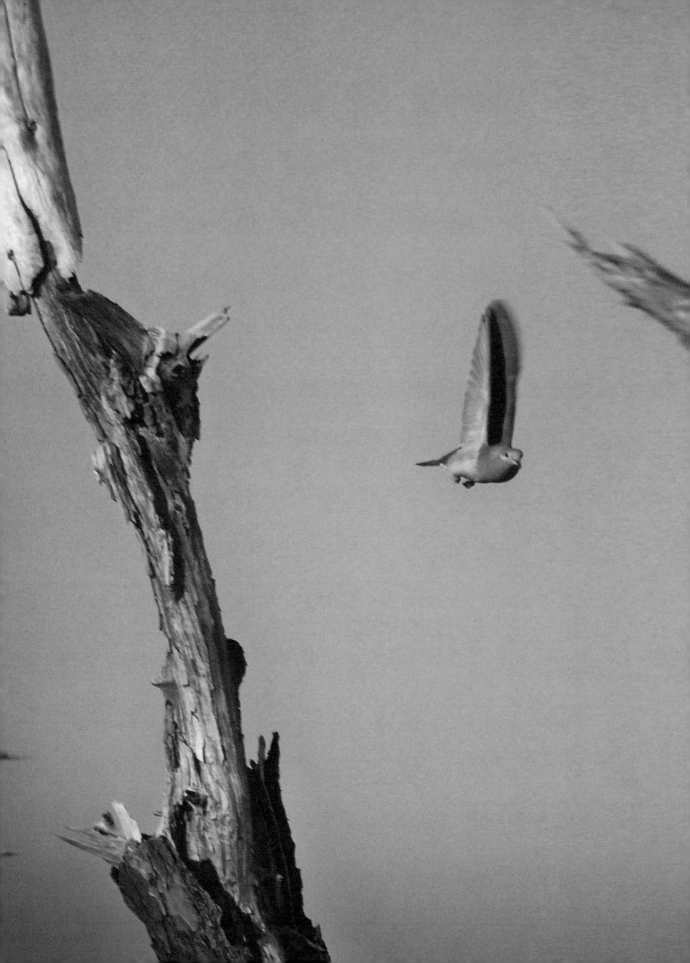

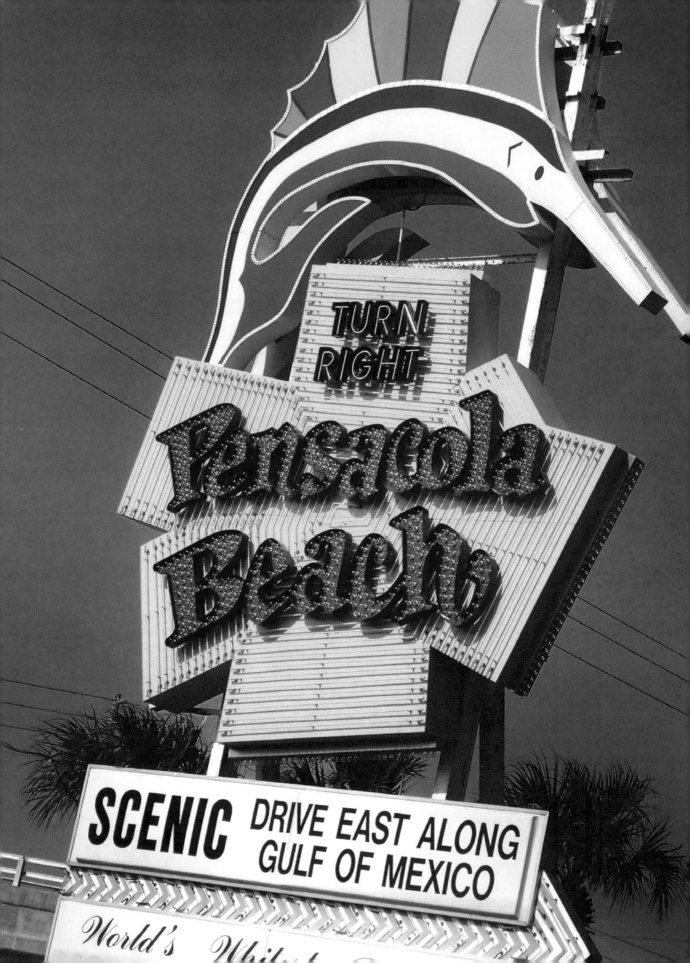

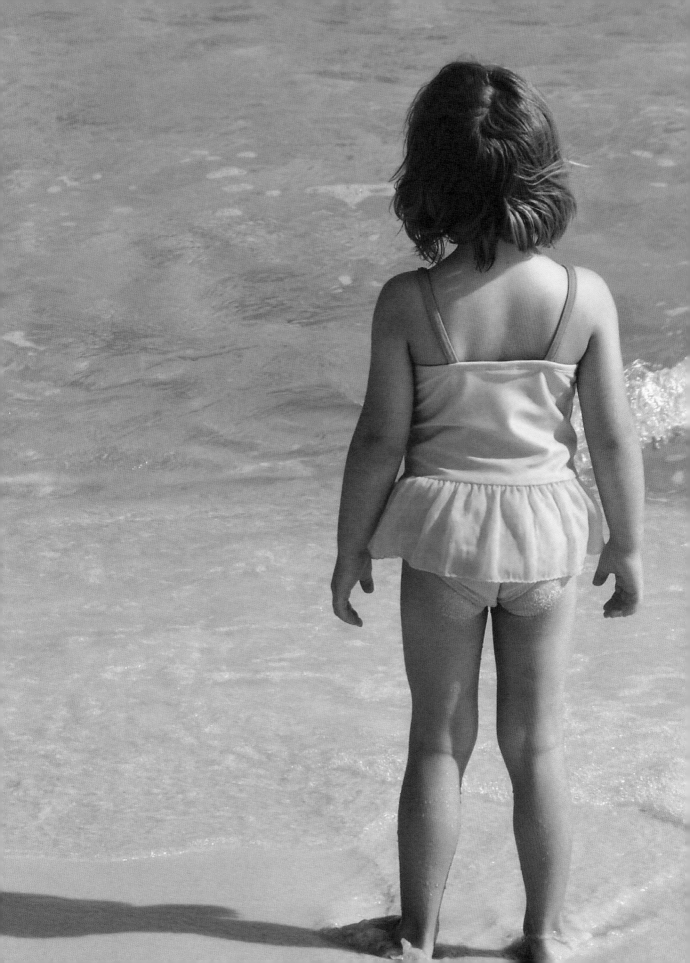

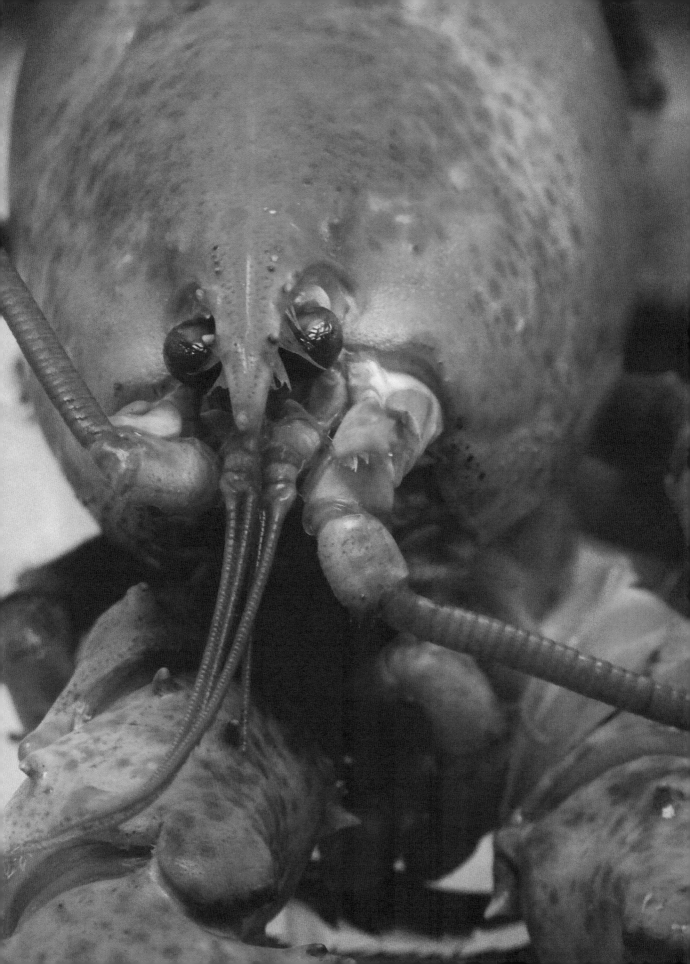

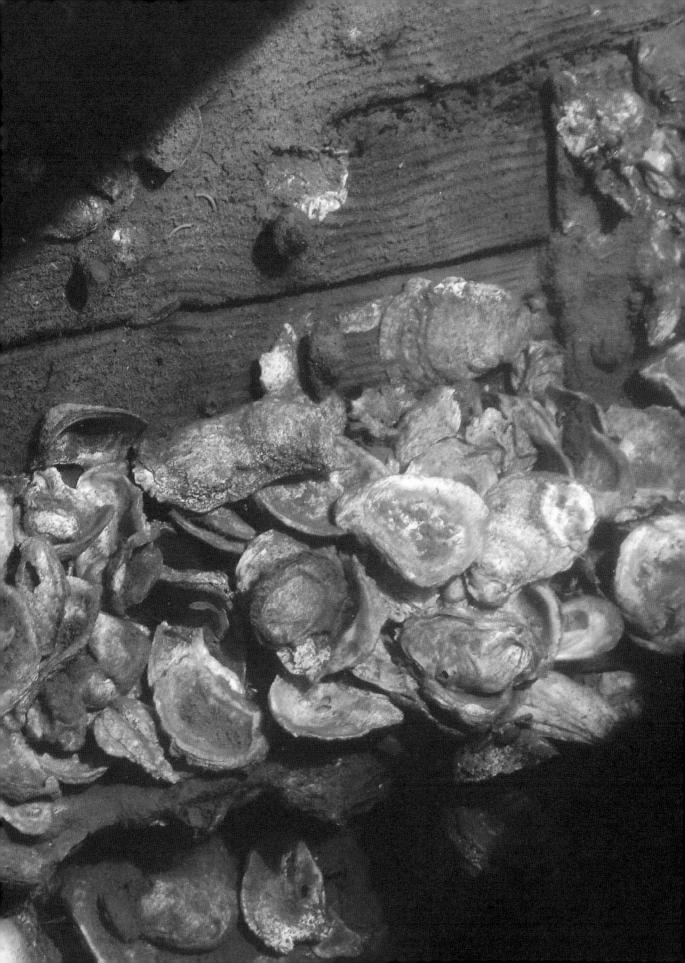

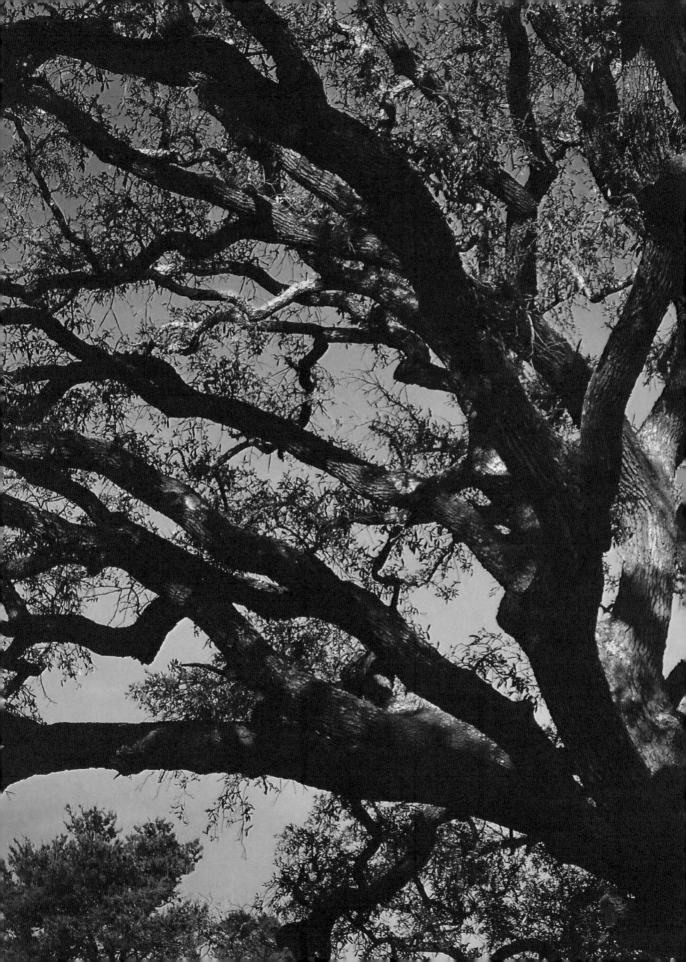

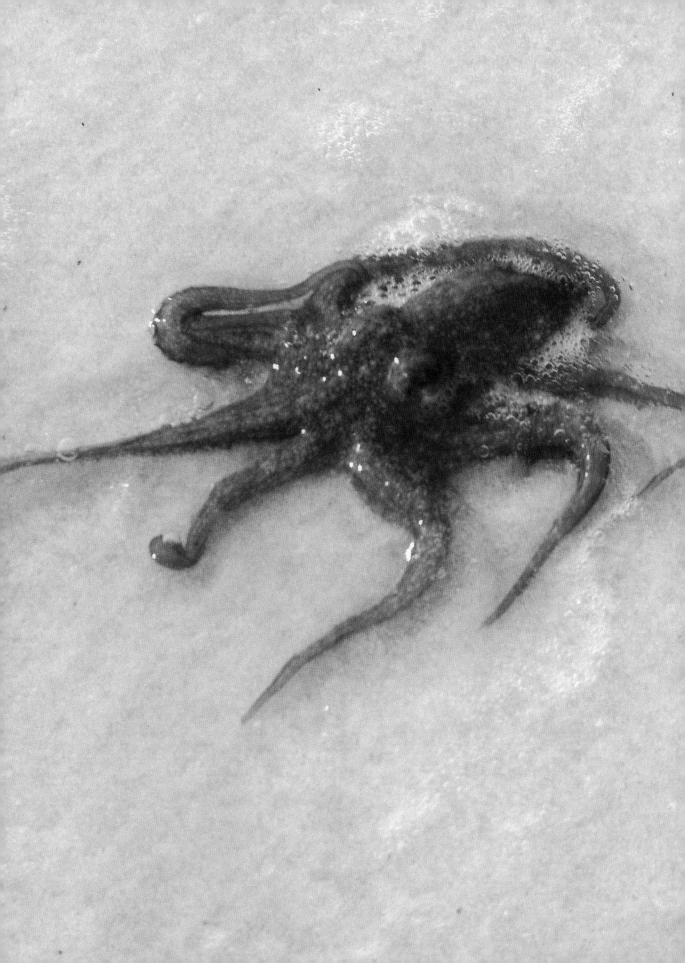

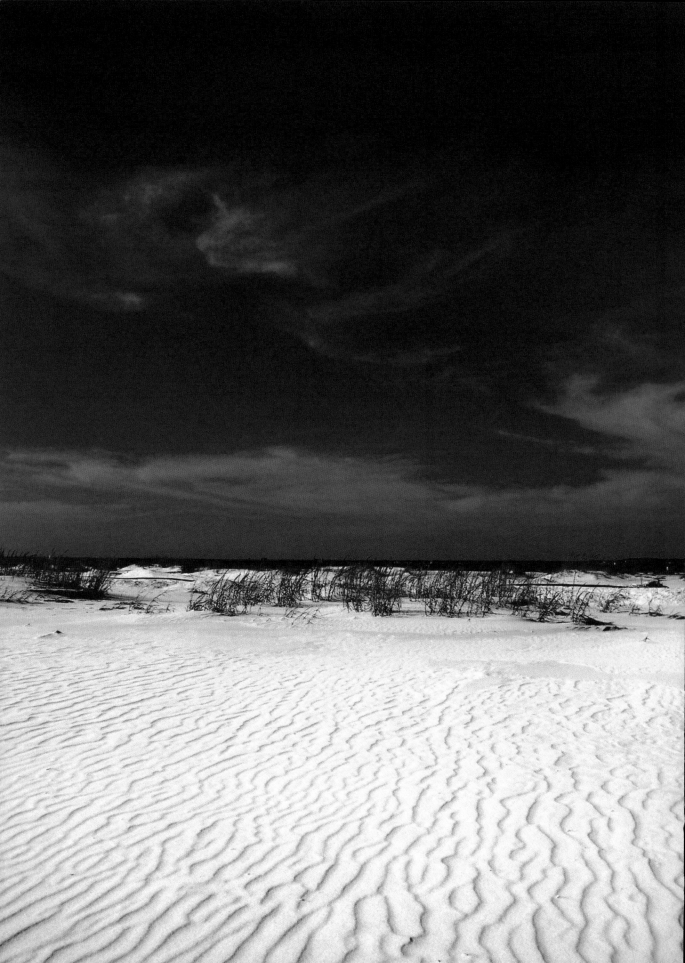

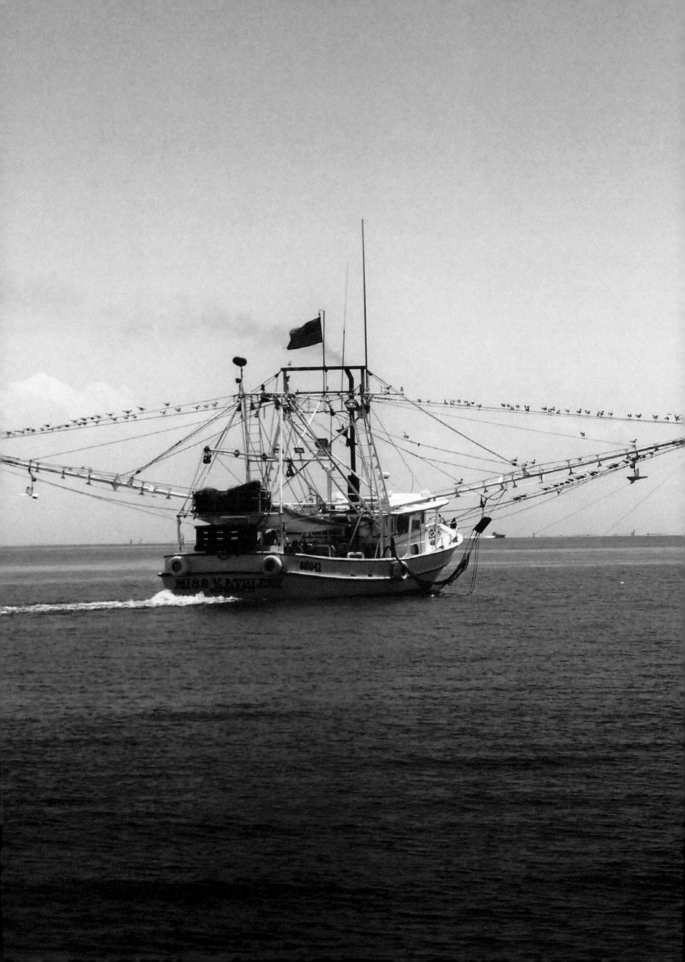

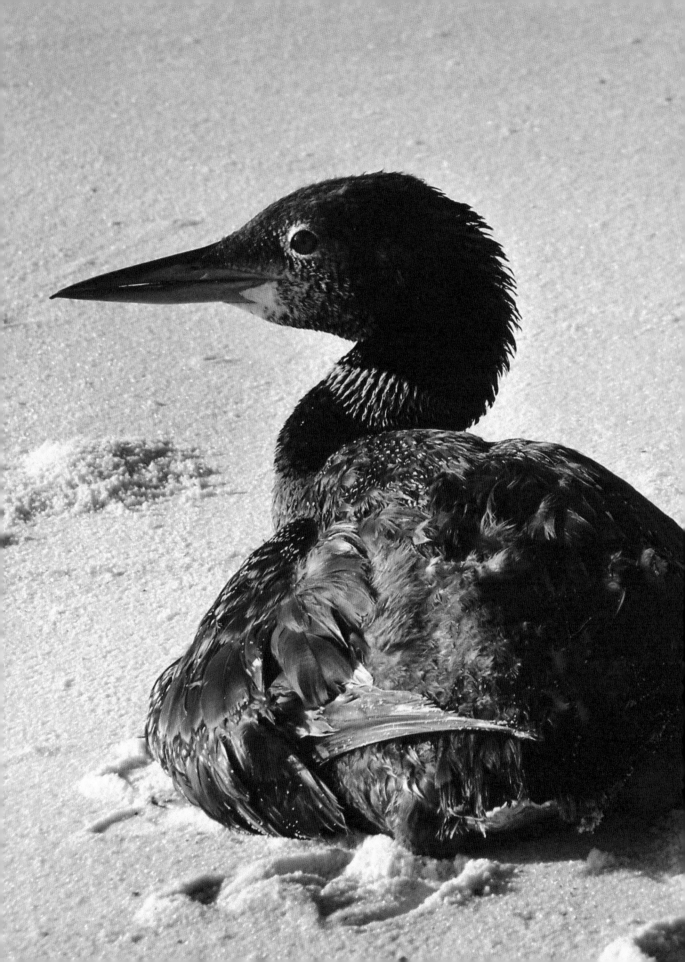

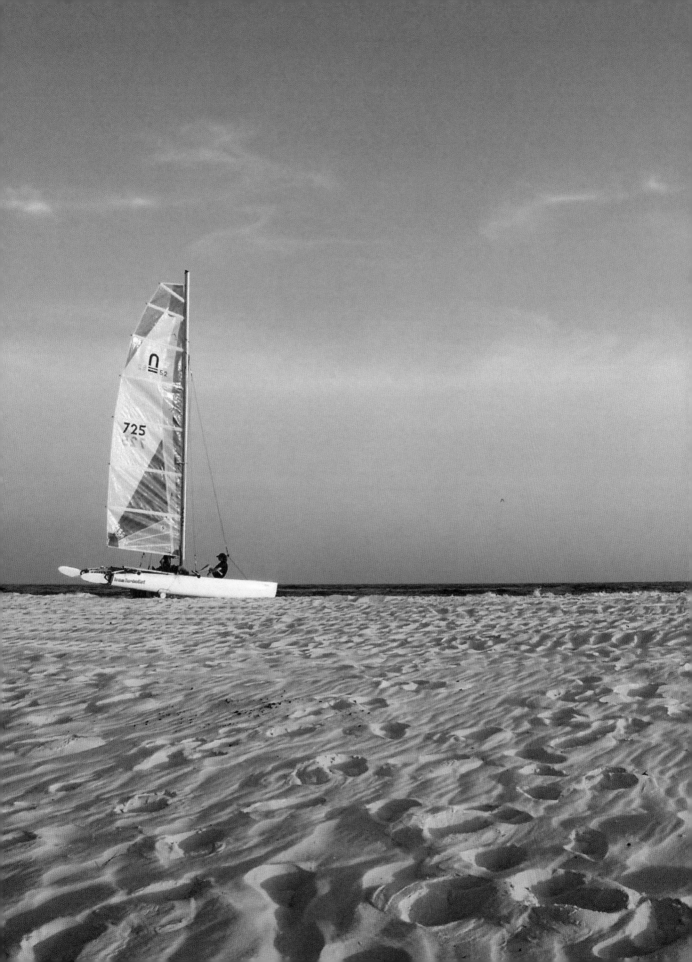

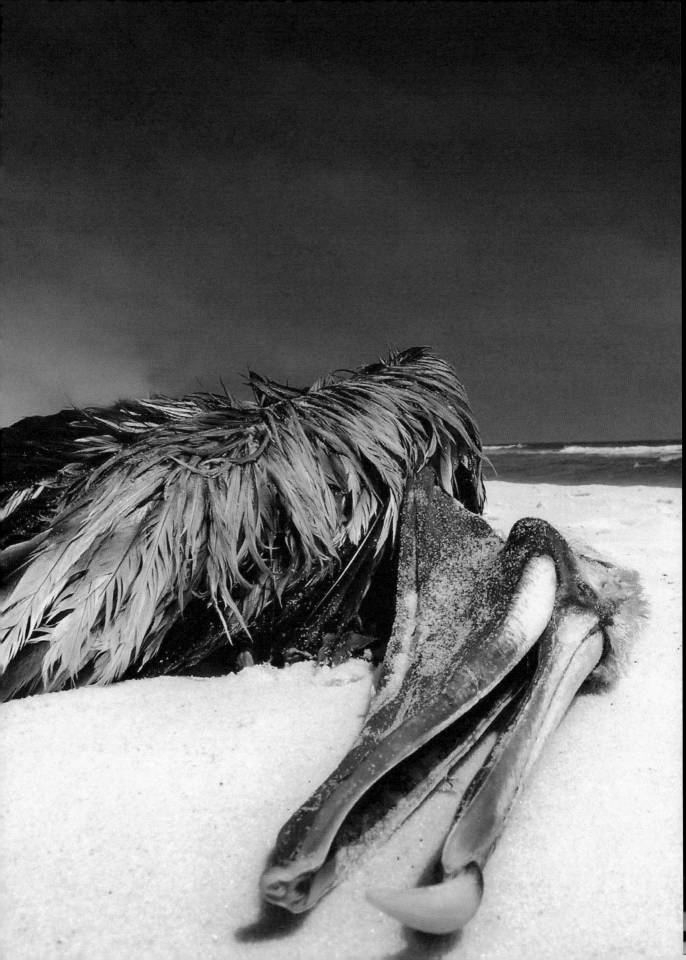

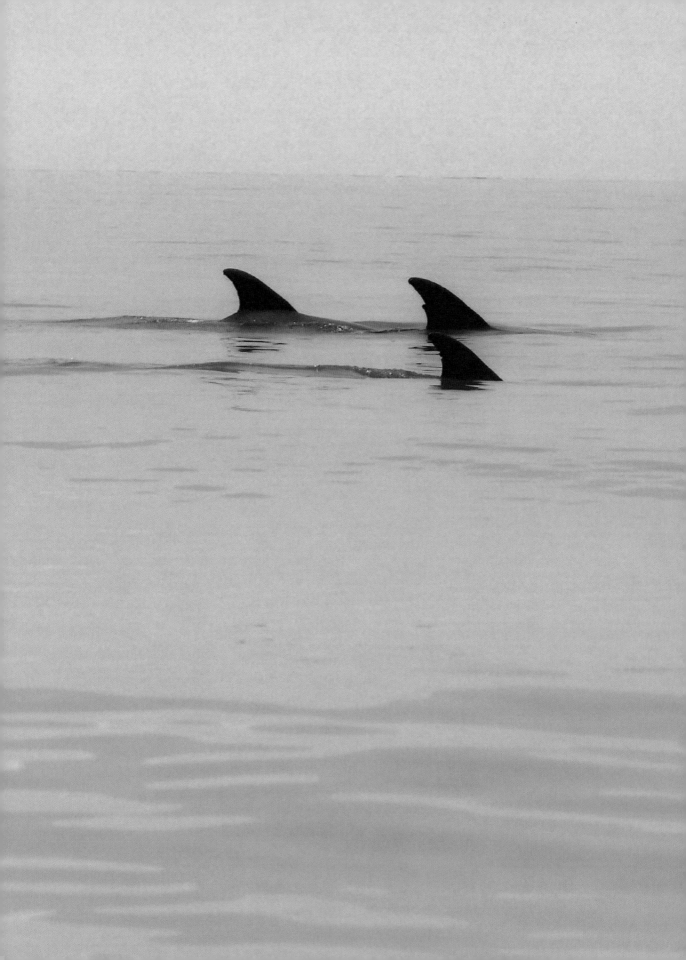

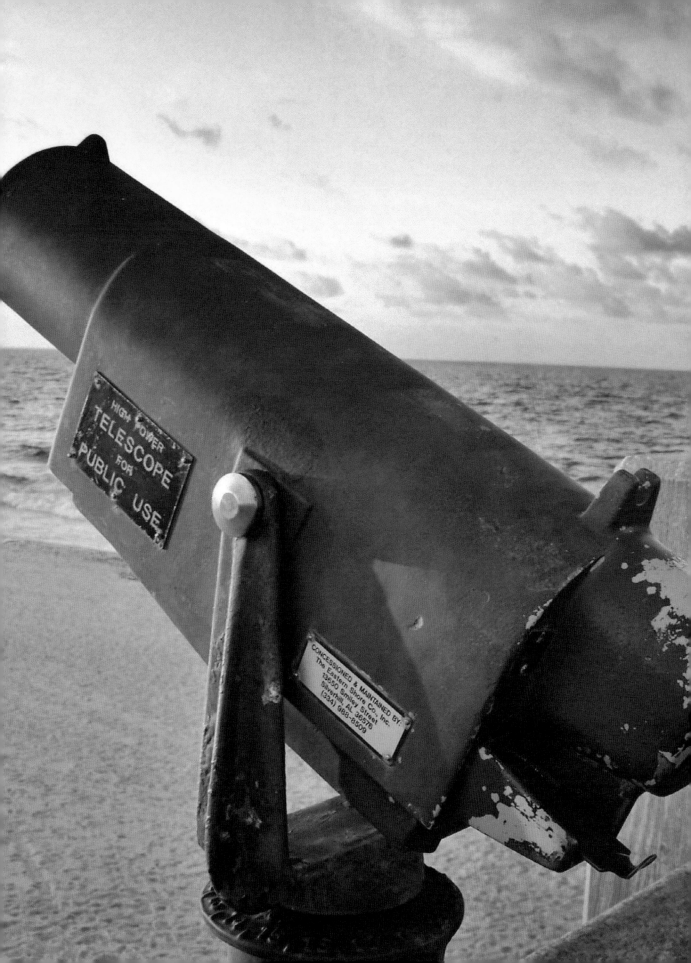

HIGH POWER
TELESCOPE
FOR
PUBLIC USE

CONCESSIONED & MAINTAINED BY:
The Eastern Shore Co., Inc.
13050 Smiley Street
Silverhill, AL 36576
(334) 988-8509

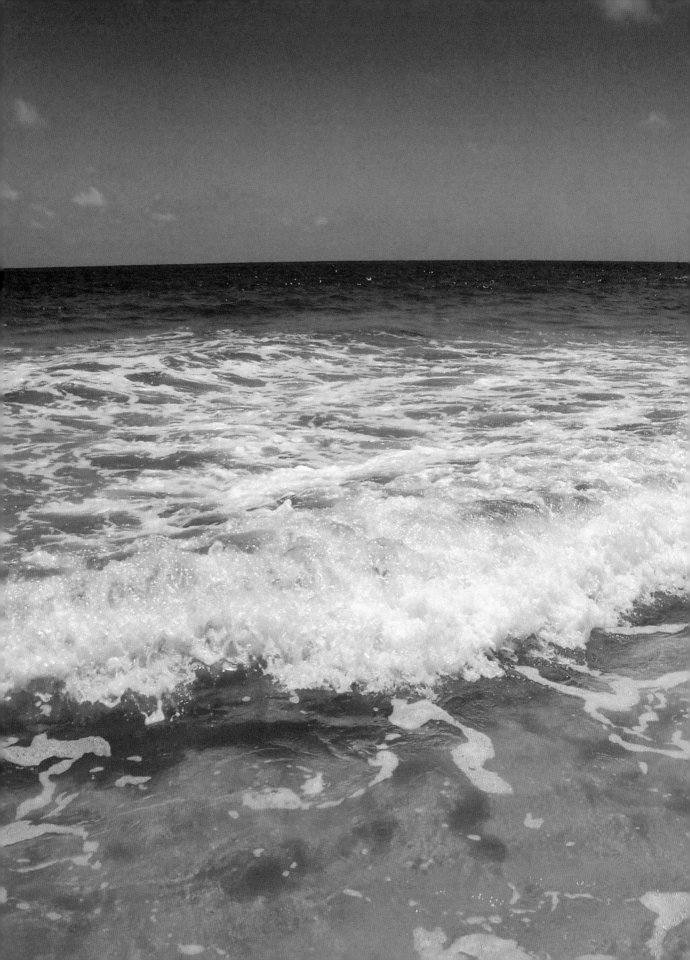

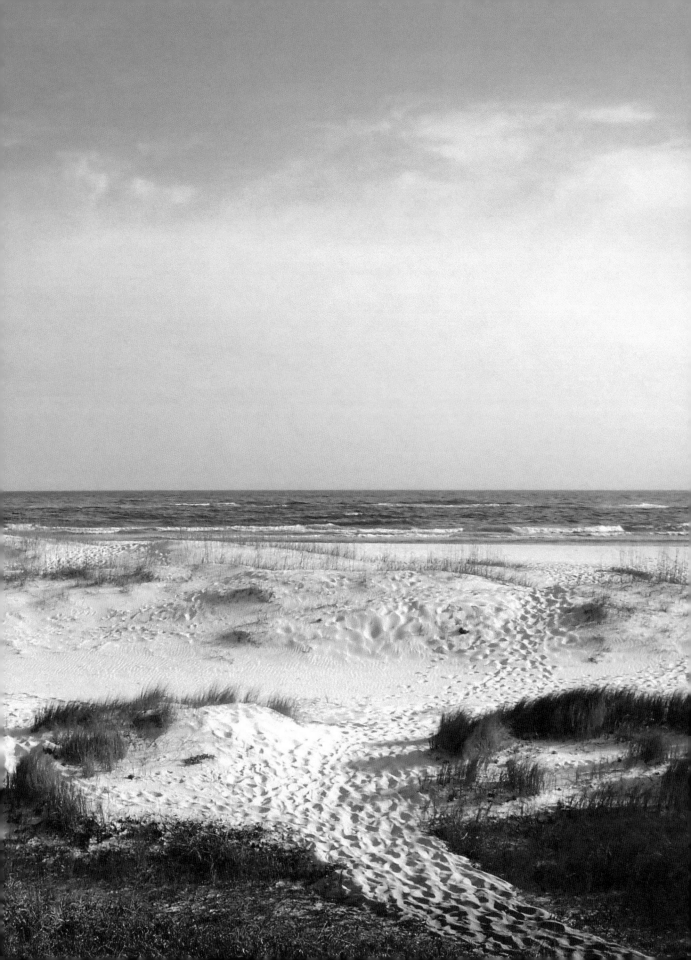

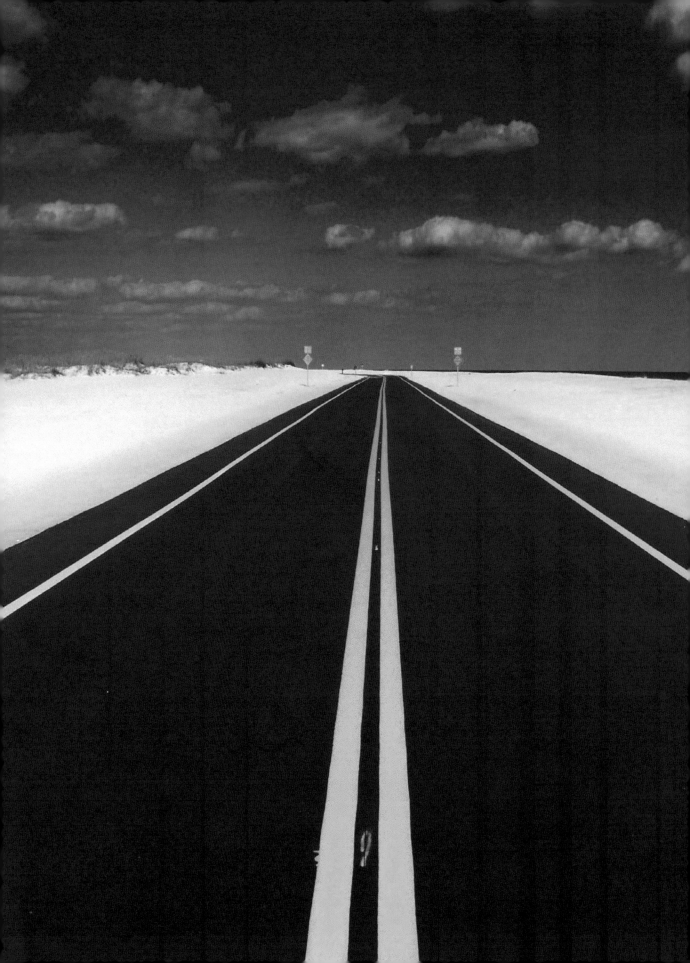

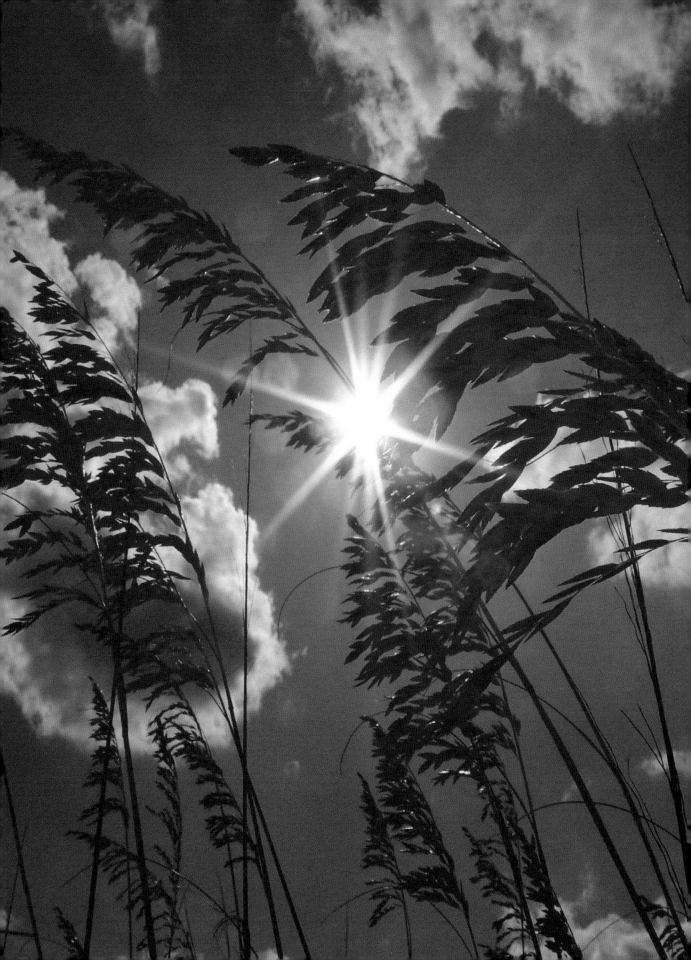

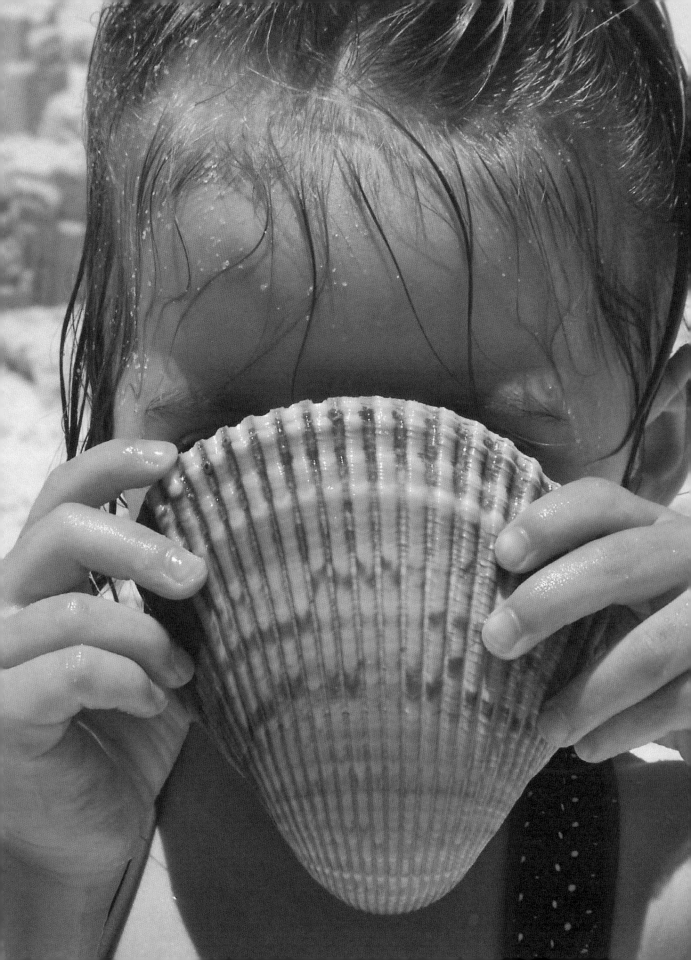

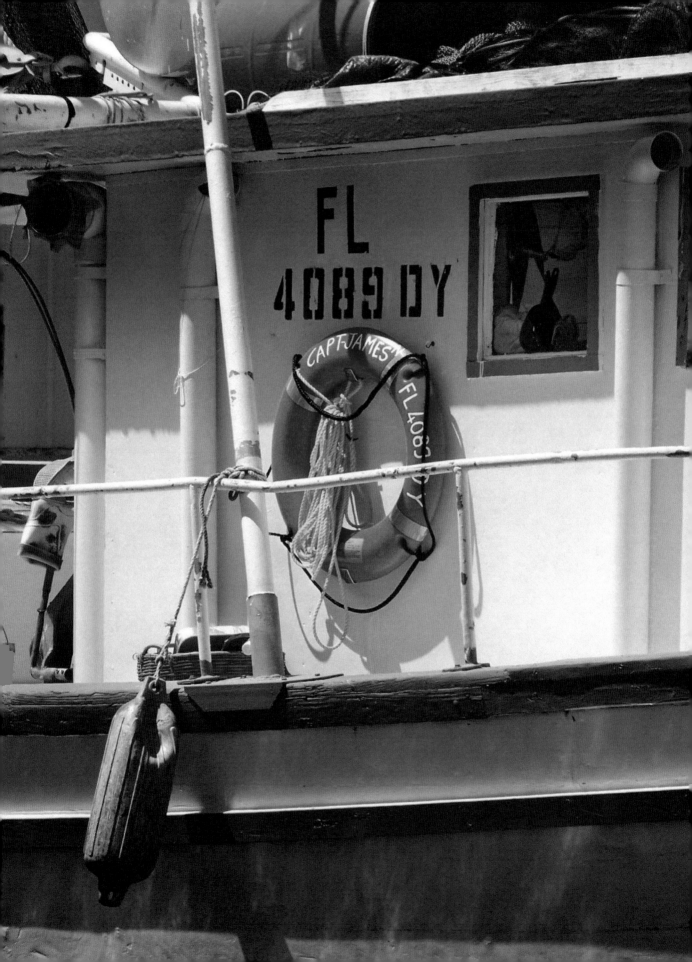

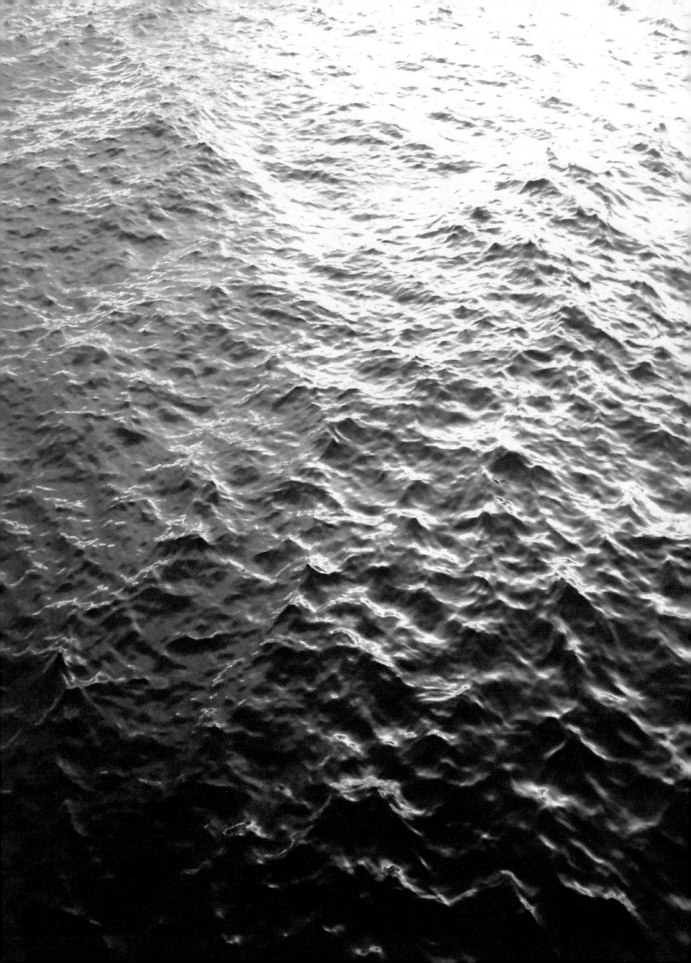

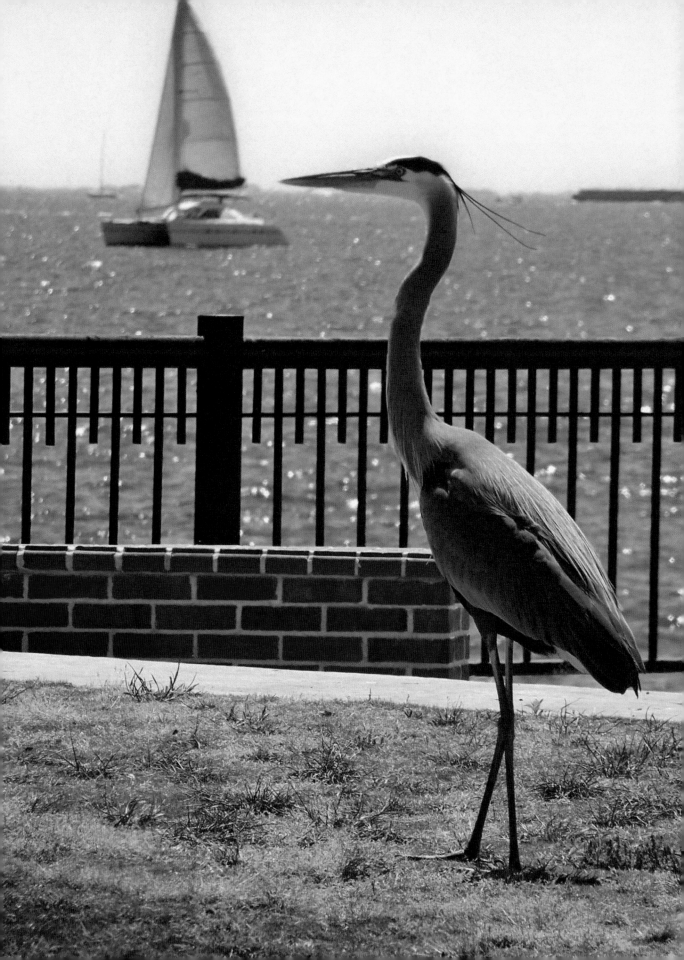

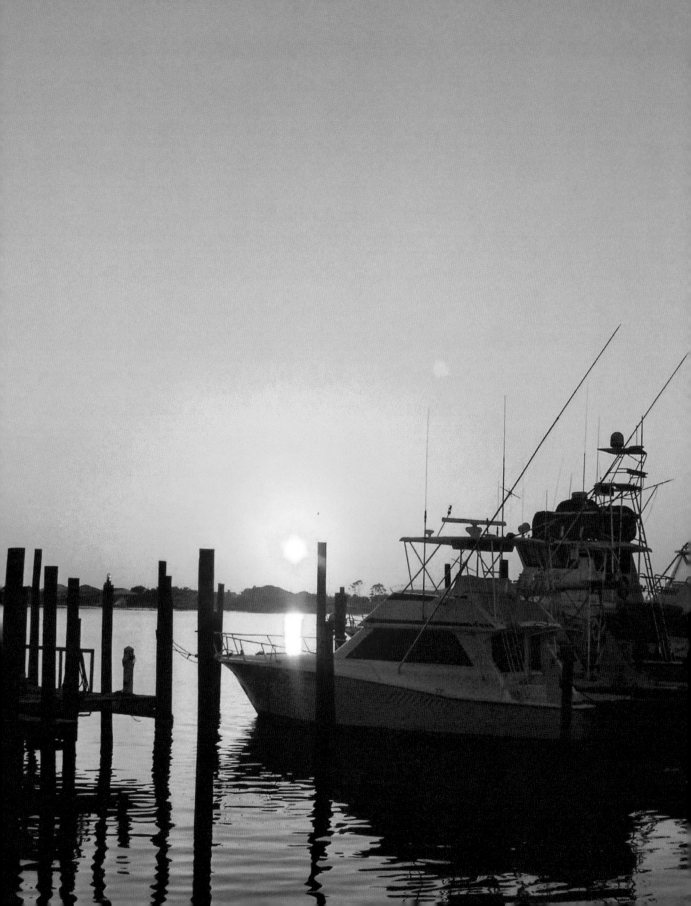

Afterword

BY

SHANE STANFORD

Extravagance in plain sight.

In 2007, the *Washington Post* organized a social experiment in the thoroughfares of the Washington Metro Subway System. Their goal was to assess whether people would respond to exceptional beauty set outside its normal context.

The plan worked like this...

A young violinist set up in one of the metro station stops and spent the next several hours playing for the daily travelers. At one point, the main provided a 45 minute presentation using several exquisite pieces from Bach.

Over the course of his time in the metro station, the young man had nearly 2,000 people pass by. Of that number, only six stopped to dialog with the man. Four of them were children, who were eventually pulled away by their rushed parents.

Though he did nothing more than open his violin case and place a sign that donations were accepted, the man received $32 dollars over the hours he played. For most people, this young man's impromptu concert was unrecognized if not unexceptional as they quickly passed to their destinations.

How little they really knew...

The young man in question was actually Joshua Bell, one of the greatest musicians in the world. The night before, Mr. Bell had sold out a concert at a large music hall in Boston where tickets went for well over $100 apiece.

The violin on which he played was one of the most expensive instruments in the world, valued at over $3.5 million. And, the pieces of music Mr. Bell played were some of classical music's most complex and some of the world's most beautiful.

If people had only known...

But, does knowing the exquisite nature of something mean that it is worth more than in its simplest form? Mr. Bell would say "no" and so would those few who, though they had no idea who was in front of them, recognized that something extravagant was in plain sight.

Think of Creation.

Does a shoreline filled with beautifully adorned resorts and tourist areas seem more beautiful than an untouched stretch of natural coastline. Of course not. In fact, the opposite is most likely true. With all of the tools humanity uses to shape and decorate nature, it is nature itself that is the most extravagant... the greatest wonder.

And, best of all, it sits right in front of us. It is present every morning and every evening for us to enjoy. Its a gift of God that we should never take for granted.

The busy life often keeps us from stopping to watch genius unfold. But, that is exactly what a sunrise or sunset becomes-- a brilliant cosmic work of art by the universe's greatest artist.

Our hope is that you will not pass by extravagance in plain sight while make the journey of life. You will not only be blessed for stopping, but you become part of the scene, part of the masterpiece.

And, so, we mourn the wounds to nature. But, we do not miss the opportunity to make those wounds sources of healing and wholeness as we learn and are restored together. The music of Creation matters, and everyone has a part to play.

Blessings.

SHANE STANFORD

SHANE STANFORD is a pastor, author and teacher. Shane currently serves as Senior Pastor of Gulf Breeze United Methodist Church and is the author of eight books including the nationally recognized *The Seven Next Words of Christ, A Positive Life,* and *The CURE for the Chronic Life* (coauthored with Deanna Favre). Shane has appeared on multiple national media outlets including *The Hour of Power, Christianity Today,* and *CNN.com.* He is married to Dr. Pokey Stanford, and they are the parents of three daughters. They reside in Gulf Breeze, Florida.

For more information, see **www.shanestanford.org**

ANTHONY THAXTON currently serves as Creative Director at Gulf Breeze United Methodist Church and as a television producer for *The United Methodist Hour.* He has won many awards for his television work, paintings, graphic design and writing. Anthony is married to Amy Thaxton, and they are the parents of two children, Bryant Curtis and Sydney Elizabeth. They happily reside in Florida but still consider themselves Mississippians.

For more information, see **www.anthonythaxton.com**

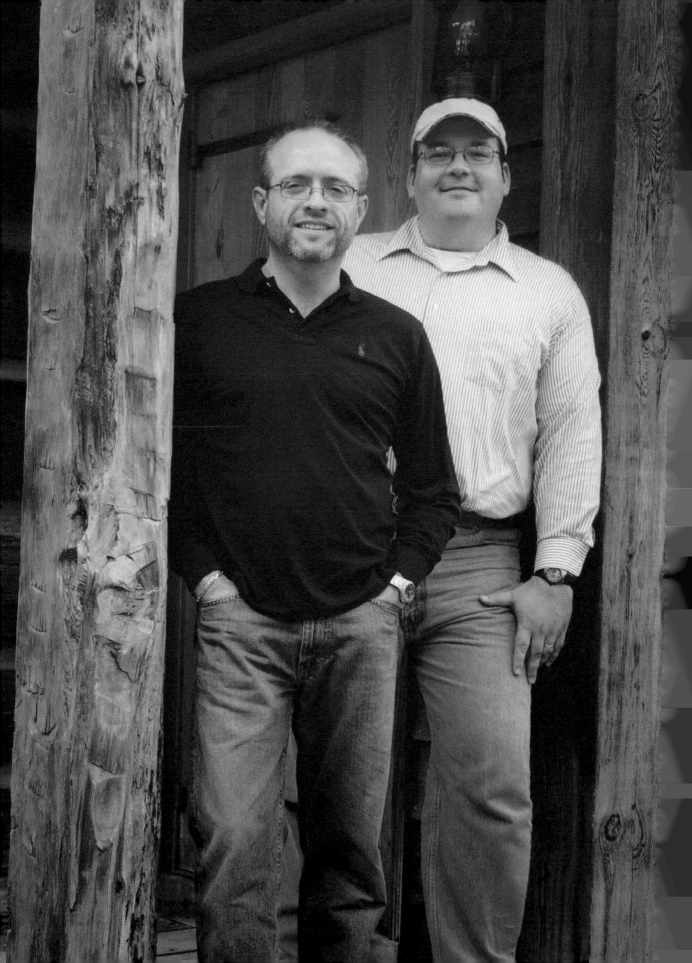